現代中國畫展

Exhibition Schedule

CHINESE CULTURE CENTER
OF SAN FRANCISCO
San Francisco, California
November 16, 1983 – February 18, 1984

BIRMINGHAM MUSEUM OF ART
Birmingham, Alabama
March 25 – May 20, 1984

ASIA SOCIETY GALLERY
New York City, New York
June 21 – August 26, 1984

HERBERT F. JOHNSON MUSEUM OF ART
(CORNELL UNIVERSITY)
Ithaca, New York
September 12 – October 28, 1984

DENVER ART MUSEUM
Denver, Colorado
December 22, 1984 – February 24, 1985

INDIANAPOLIS MUSEUM OF ART
Indianapolis, Indiana
March 19 – May 19, 1985

NELSON-ATKINS MUSEUM OF ART
Kansas City, Missouri
July 12 – September 1, 1985

UNIVERSITY ART MUSEUM
UNIVERSITY OF MINNESOTA
Minneapolis, Minnesota
September 23 – December 1, 1985

The Chinese names and terms are romanized according
to the Pinyin system.

Designed by Gordon Chun
Photography by James Medley
Chinese title inscribed by Li Keran

Published by the Chinese Culture Foundation of San Francisco
Printed by EBSCO Media, Birmingham, Alabama 35201—1943

Library of Congress Catalogue Number 83-72835
ISBN 0-9609784-8-8, 0-9609784-9-6

Contemporary Chinese Painting
An Exhibition from the People's Republic of China

Organized by

Lucy Lim
Executive Director/Curator
THE CHINESE CULTURE CENTER OF SAN FRANCISCO

舊金山中華文化中心

in cooperation with

THE CHINESE ARTISTS' ASSOCIATION OF THE PEOPLE'S REPUBLIC OF CHINA

中國美術家協會

Essays Contributed by:

James Cahill

Michael Sullivan

Lucy Lim

Chinese artists and critics
(in translation)

Funding Acknowledgments

THE CHINESE CULTURE FOUNDATION OF SAN FRANCISCO ACKNOWLEDGES WITH THANKS THE FOLLOWING ORGANIZATIONS FOR THEIR MAJOR FUNDING SUPPORT THAT HAS MADE THIS EXHIBITION PROJECT POSSIBLE:

National Endowment for the Arts, *a Federal agency*

California Arts Council

San Francisco Hotel Tax Fund

The Starr Foundation, *New York*

The George Frederick Jewett Foundation, *San Francisco*

The Hearst Foundation, *New York & San Francisco*

The Columbia Foundation, *San Francisco*

ADDITIONAL SUPPORT IS PROVIDED BY THE FOLLOWING:

Foremost-McKesson Foundation, Inc.,
 San Francisco

BankAmerica Foundation, *San Francisco*

Charles Ulrick and Josephine Bay Foundation, Inc.,
 New York

Mary Livingston Griggs and Mary Griggs Burke
 Foundation, *Minneapolis*

Fireman's Fund Insurance Company Foundation,
 San Francisco

The Society for Asian Art, *San Francisco*

Asian Cultural Council, *New York*

Mortimer Fleishhacker Foundation, *San Francisco*

The Birmingham Asian Art Society, Inc., *AL*

Chevron U.S.A., Inc., *San Francisco*

Walter and Elise Haas Fund, *San Francisco*

EBSCO Industries Inc., *Birmingham, AL*

Louis R. Lurie Foundation, *San Francisco*

California Council for the Humanities

The Dillon Fund, *New York*

THE CHINESE CULTURE FOUNDATION ALSO THANKS THE FOLLOWING INDIVIDUALS FOR THEIR GENEROUS CONTRIBUTIONS:

Anonymous, *New York* and *San Francisco*

Alice Boney, *New York*

Andrea Comel di Socebran, *San Francisco*

Jeannette Shambaugh Elliott, *Tucson, AZ*

Mrs. Mortimer Fleishhacker, *San Francisco*

Han Suyin, *Lausanne, Switzerland*

Martha M. Hertelendy, *Oakland, CA*

Dr. and Mrs. Clinton Lee, *Piedmont, CA*

Dr. and Mrs. George Leong, *Atherton, CA*

Sally Leung, *San Francisco*

Dr. and Mrs. Rolland C. Lowe, *San Francisco*

Jane R. Lurie, *San Francisco*

I.M. Pei, *New York*

Mrs. Joan Seaver, *Los Angeles*

Ms. Joan Sutherland, *Los Angeles*

Eileen Tong, *San Francisco*

C.C. Wang, *New York*

Mrs. Paul L. Wattis, *San Francisco*

Mr. and Mrs. Art T. Wong, *Los Altos Hills, CA*

Edward C. Young, *Piedmont, CA*

Table of Contents

Chinese Chronology

Xia Dynasty	c. 2100-1600 B.C.
Shang Dynasty	c. 1600-1027 B.C.
Zhou Dynasty	1027-221 B.C.
Qin Dynasty	221-206 B.C.
Western Han Dynasty	206 B.C.-A.D. 8
Wang Mang Interregnum	9-23 A.D.
Eastern Han Dynasty	25-220
Three Kingdoms	220-280
Western Jin Dynasty	265-316
Eastern Jin Dynasty	317-420
Northern and Southern Dynasty	420-581
Sui Dynasty	581-618
Tang Dynasty	618-906
Five Dynasties	906-960
Song Dynasty	960-1279
Yuan Dynasty	1279-1368
Ming Dynasty	1368-1644
Qing Dynasty	1644-1911
Republic of China	1911-1949
People's Republic of China Founded	1949

China

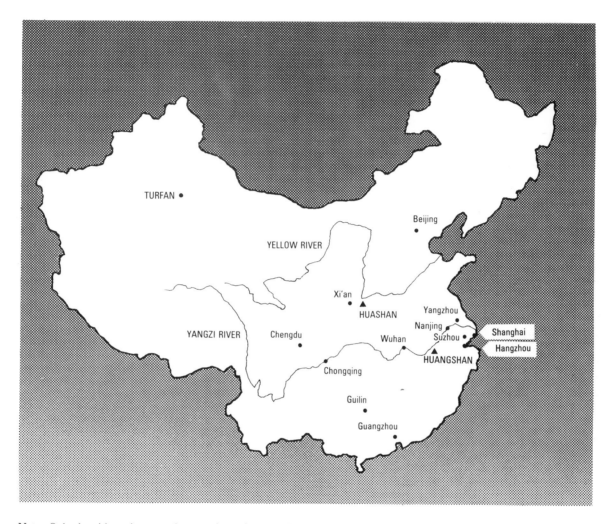

TURFAN •

Beijing •

YELLOW RIVER

Xi'an •
▲
HUASHAN

Yangzhou

YANGZI RIVER Chengdu •

Nanjing

Wuhan • Suzhou •

Shanghai

Hangzhou

▲
HUANGSHAN

Chongqing •

Guilin •

Guangzhou •

Note: Only the cities, rivers, and mountains referred to in the texts are indicated on this map.

前　言

中國美術家協會非常高興有機會把現代中國畫提供給美國觀眾欣賞。

中國畫具有悠久的歷史傳統，它和西方繪畫傳統無論在技法、工具和材料上都是很不相同的。西方人過去對古老的東方繪畫有過接觸和愛好，但是對新中國現代的中國畫很可能是陌生的。這個展覽所展出的六十六幅作品將會提供給觀眾一些有趣的問題：當社會發展進入新時期的時候，藝術是否能繼承已往的優秀傳統？它是一成不變的，還是有所發展？新中國的藝術是否會同世界各地的藝術向着同樣的方向走下去？這些將由觀眾從展出的作品中找答案。

中國美術家協會需要說明的是這個展覽的作品只是在現代中國的歷史時期，在中國的土壤條件下所成長煥發的花朵，它們是豐富多彩的。在這次的展出中，山水花鳥占大多數，當然這不是現代中國繪畫的全貌。但這樣規模地向美國觀眾介紹一種類型的美術，可以說是第一次。爲此，我們向美國舊金山中華文化中心和其他贊助機構和人士表示深切的謝意。

中國美術家協會希望通過這個展覽進一步加深中美兩國美術家和人民的相互了解和友誼，并借此機會向美國美術家和美國人民致以友好的熱烈問候。

中　國　美　術　家　協　會

Foreword

The Chinese Artists' Association is very pleased to have the opportunity to present this exhibition of contemporary Chinese painting in the traditional style for the appreciation of the American audience.

Chinese painting has a long historical tradition. It is very different from the tradition of Western painting, not merely with regard to implements and materials. In the past, Western audiences have had many occasions to see and appreciate ancient paintings of the East. But to them, contemporary painting in the new China is probably not a very familiar subject.

This exhibition of sixty-six paintings and sketches should bring up some interesting questions in the minds of the viewers: When a society progresses into a new age, is its art still capable of absorbing and continuing the artistic legacy that it has inherited? Will the artistic tradition remain unchanged, or will it branch out in new directions? Is the art of the new China going in the same direction as that of the other nations in the world? The audience will have to find the answers to these questions from this exhibition.

The Chinese Artists' Association would like to say that the paintings in this exhibition, rich in variety and themes, have all been produced and created in our time—in today's China. Although landscapes, bird and flower paintings comprise a major portion of the exhibition, they do not by any means reflect the entire scope of contemporary Chinese painting. This is, nevertheless, the first time that an exhibition on this scale devoted to painting in China today has been mounted for the American audience. For this effort, we thank the Chinese Culture Center of San Francisco and the various organizations and individuals who have assisted in the project.

The Chinese Artists' Association hopes to further the understanding and friendship between the United States and China through this exhibition. At the same time, it extends its warm regards to the American artists and the American people.

Chinese Artists' Association
People's Republic of China

Preface and Acknowledgments

In presenting "CONTEMPORARY CHINESE PAINTING: An Exhibition from the People's Republic of China", we wish to thank Consul Xie Heng of the Chinese Consulate in San Francisco (who has just moved to the Chinese Embassy in Washington, D.C.) for facilitating this cultural-exchange project, and for the personal concern and interest that she has shown in every stage of the planning. Cultural Minister Counsellor Wang Zicheng of the Chinese Embassy also rendered his assistance whenever necessary.

Without the cooperation and support of the Chinese Artists' Association, we could not have carried out this project. I am especially grateful to Mr. Jiang Yousheng, Mr. Feng Xuming, Mr. Zhou Baohua, Mr. Lin Xiaoping (now at the Central Art Academy), and—in particular—to Ms. Zhang Quan, who worked long hours and under great pressure to gather the paintings and the related materials for us. The Association made arrangements for me to travel all over China to select the paintings for the exhibition with unrestricted freedom. Chinese artists provided much help and many suggestions. We would have liked the show to be much more comprehensive in scope, but this was not possible because of our limited gallery space and resources.

Professor James Cahill, of the University of California at Berkeley, is art advisor to the Chinese Culture Center and the project. He has given his time and advice generously at all times, besides contributing an essay to the catalogue. Professor Michael Sullivan, of Stanford University, graciously consented to be an advisor to the project, upon our invitation, when we finally reached him, and has also contributed an essay. We are very honored to have these two distinguished scholars involved with this project, which includes a symposium as well as the exhibition.

Writer Jade Snow Wong, a friend of the Chinese Culture Foundation, has given her time and help unstintingly. Mr. Andrea Comel di Socebran assisted with various aspects of the exhibition with remarkable results, in China and in San Francisco. Photographer Kit Luce donated his time and efforts to help me take slides of the paintings, the artists, and their environment in China, sometimes done under very trying conditions.

To our Board of Directors and our small staff, I express my deep thanks for their cooperation and support. Ms. Laura Newton and Ms. Carol Stepanchuk, in particular, worked very hard to meet deadlines. The catalogue entries were compiled by Ms. Stepanchuk, who also translated the Chinese biographical data on the artists into English, with some assistance from Mr. Cheng Duo-duo. Ms. Newton assisted in the editing, and we thank Mr. Scott Jones for editorial consultation.

Needless to say, without the funding support from the various organizations and individuals named on the Funding Acknowledgments, this project could not have become a reality. I personally wish to thank the National Endowment for the Arts for awarding me a Literature Program writing fellowship in 1978 and a Museum Professional fellowship in 1982, which enabled me to explore the cultural scene in China extensively, including new developments in contemporary Chinese art.

To the above, and to many others who have contributed in one way or another, we express our sincere thanks and gratitude.

Lucy Lim
Executive Director/Curator
Chinese Culture Center of San Francisco

Essays

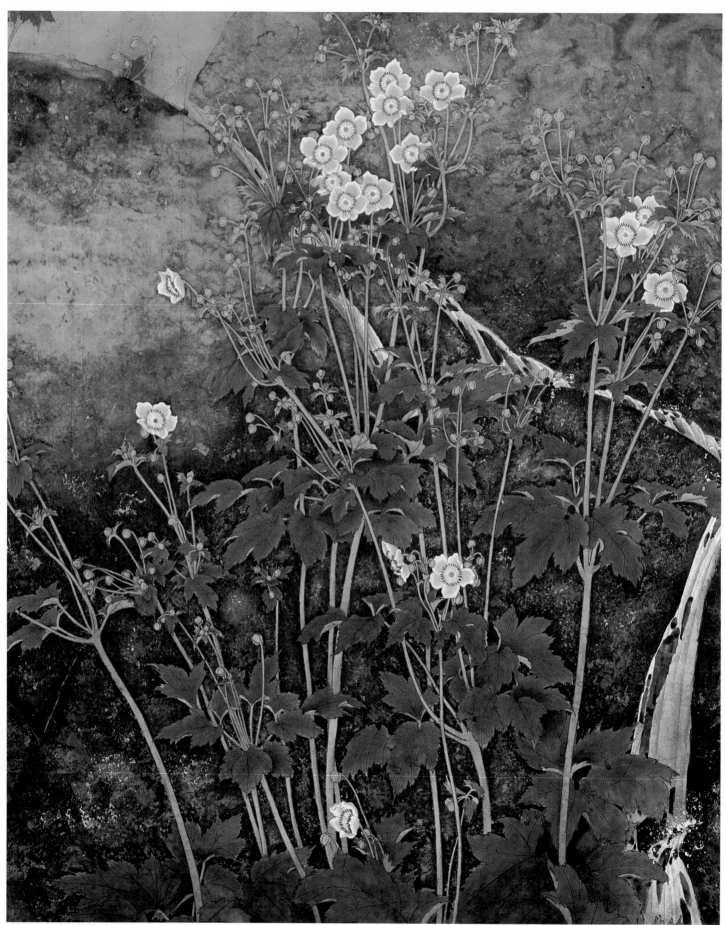

Detail of Plate 61

Introduction

Lucy Lim

Much of Chinese painting in the past was embedded in the fabric of Chinese society: art was too often an act of persuasion, created to serve a social, didactic role. This was especially true during the Han dynasty, as early as the first century B.C., when Chinese art came under the domination of the Confucian ethical code that became the standard of moral conduct for Chinese society. Figure painting prevailed during that time, subordinated to the orthodox Confucian tradition: the figures depicted in these early paintings were usually Confucian exemplars of moral behavior. Besides frequently being members of the ruling elite, they were portrayed so that they would be emulated, their purpose being to inspire and instruct the viewers. This socially oriented art and its values came to characterize Chinese painting intermittently in the centuries that followed.

The People's Republic of China was founded in 1949 and socialism became the new state ideology. Ironically, while Confucianism came under a series of attacks during the reforming movements, Chinese art became more didactic, doctrinaire, and persuasive than it ever was in Chinese history. Hortatory concerns abound, exhorting viewers to adhere to the socialist ideals. Indeed, in 1942, the late Chairman Mao Zedong at the Yenan Forum had proclaimed rigorous guidelines for artists and writers: "All our literature and art are for the masses—for workers, peasants, and soldiers."

A poster-style propaganda art developed, strongly influenced by Soviet socialist-realism and usually painted in oil on canvas. Peasant painting, said to be produced strictly by amateurs—farmers and workers—in their spare time, was another outgrowth of Maoist doctrine. (An exhibition of peasant painting toured the United States in 1977 and 1978, and was displayed at the Chinese Culture Center in San Francisco.) Happy, grinning faces with shiny bright teeth were the standard feature among the people depicted, who seemed to burst with health. They were often represented with clenched fists in a gesture of triumph: all was well with the new society, and the future was promising. Farms and fisheries were shown in full productive abundance, demonstrating a prospering new economy. Panoramic murals of China's awesome natural landscapes

decorated many public buildings, intended to instill pride in the national heritage.

It was a revolutionary art. Art served ideology, espousing the revolutionary cause. More often than not, it was used as a political tool, its artistic value denigrated by mass appeal: form follows function. The art created in the early decades of the People's Republic fulfilled the social needs of the time. China was a nation torn and demoralized by internal conflicts and foreign invasions. The revolution that brought about the establishment of the People's Republic was an effort to revitalize the nation, ensnared for so long by its feudalistic traditions. The old hierarchy of social values was advantageous to the élite but had no worth for the ordinary, common folks, especially the peasants.

Ever since 1958, and especially during the Cultural Revolution and the Jiang Qing years (1966 to 1976), traditional art forms had been under attack. They were roundly criticized for their "bourgeois", "elitist", and "decadent" content. In 1974, an incident at the Beijing Hotel caused many painters to abandon their art altogether. During a small showing of traditional paintings by several well-known artists, Jiang Qing—Mao's wife and leader of the so-called "Gang of Four"—accused the traditional painter Li Keran of promulgating "dark" thoughts and secret plots in his "black paintings"—landscapes painted in heavy black ink. Huang Yongyu was accused of expressing veiled discontent with the regime for the way he depicted his owls, with one eye closed. Other traditional artists drew criticism for their lack of attention to political content. The period from 1966 to 1976 is known in China today as the "Black Decade", when traditional artists and intellectuals were severely persecuted and had to endure years of privation. Bitter memories of that time remain in most artists' minds today.

The end to the "Black Decade" came with Mao's death and the subsequent demise of the "Gang of Four" in 1976. The new slogan in Chinese painting was "let a hundred flowers bloom" ("*baihua qi fang*"), and a flowering did indeed take place. A general cultural thaw brought about a resurgence of traditional art forms. But the process was gradual. Visitors to China—such as myself—did not see

the revival of the traditional style of Chinese painting, or *guohua*, until around 1978 and 1979. (On an earlier trip made in 1975, I saw no contemporary Chinese painting in the traditional style.) The first major exhibition of modern *guohua* Chinese painting was probably the one that took place at the Chinese Art Museum (*Meishuguan*) in Beijing in 1978, during the October 1 national celebrations, at which I happened to be present. This huge show occupied the entire two floors of the museum, and was comprised of about two hundred paintings by a large number of artists, all of the twentieth century. Some were celebrated masters such as Qi Baishi and Pan Tianshou who were no longer living, but there were also works by young, then-unknown artists—who today, however, are acquiring their own renown.

At about the same time, a major retrospective of traditional Chinese ink-and-brush paintings by the late Fu Baoshi—who died in 1965—was also presented. What was so interesting about Fu Baoshi's show—at least to me—was that it demonstrated the marvelous range and variety that this single artist was capable of, in works that were all of consistently high quality. Many of them were masterpieces. His paintings executed in the more traditional Chinese styles (many of which are evocative of ancient Chinese paintings and may be seen in collections outside China) were juxtaposed with paintings done in traditional ink and brush but which were stylistically influenced by socialist-realism. Many artists had attempted such a fusing, under the dictates of official policy, but their results were banal failures. Yet in the hands of this great master, considered by many to be one of the most important and original painters of twentieth-century China, the penetration of realism into traditional Chinese art was achieved in such a manner that it enlivened it. Fu Baoshi's contribution in painting of this type is truly remarkable, for he retained consummate mastery of his art, while following the dictates of various styles. Unfortunately, his paintings influenced by socialist-realism have not, to my knowledge, been exhibited outside China.

Fu Baoshi exerted great impact on later Chinese artists, especially those from the Nanjing region, loosely termed the *"Jinling"* school of painting. His

abstract-expressionist style of somber landscapes—usually done in tones of brown and grey—characterized by free, sketchy "hemp-fiber" texture strokes (*pima cun*) combined with the "splashed-ink" (*pomo*) washes that appeared as though they were applied at random, is sometimes visible in the works of Ya Ming and Song Wenzhi, two prominent artists of Nanjing whose works are represented in this exhibition (no. 47 and nos. 36, 37 respectively). This is not to say that the work of these two contemporary painters is simply derivative, but to indicate the stylistic continuity that is occasionally discernible in Chinese painting today. Obviously, an exhibition of this nature, in which an artist is represented by only one or two or—at most—four pieces of work, does not do justice to the individual artists.

This exhibition of contemporary painting from the People's Republic of China, which I have organized for the Chinese Culture Center of San Francisco in cooperation with the Chinese Artists' Association in Beijing and its various regional branches, is designed to record the revival of traditional painting in China today—the artistic links with the past that are evident in contemporary Chinese painting, as well as the new directions and innovations that have occurred so rapidly in the past few years after the Cultural Revolution.

Viewed against the political background of recent decades and in the context of contemporary Chinese culture, such an exhibition seems to me both timely and meaningful, particularly since it covers a new area of Chinese art yet to be explored that has increasingly engaged the serious attention of scholars, collectors, and lovers of Chinese painting. Professor James Cahill and Professor Michael Sullivan, two highly respected senior scholars in the field of Chinese painting, share this idea, and generously responded to my request for assistance to act as advisors to the project. Both have traveled extensively in China and are familiar with the contemporary Chinese art scene. Each has contributed an essay to the catalogue.

The synthesis of the old and new, the impact of socialist-realism on Chinese painting, the infiltration of Western and Japanese influences, the traditional and the innovative are among the issues discussed in the essays. They are also the criteria used to select the paintings on view. Although quality was the determining factor in the selection process, having sought the best works as much as possible in the final selection made during my last trip to China in April and May, 1983, I have included certain paintings because they represent new trends or have meaningful connections with the past. Regional representation was also a consideration, but the best works to be found in China today are mostly in Beijing, Shanghai, Nanjing, and Hangzhou, with a few exceptions. Some of the paintings selected are not considered by the artists who painted them to be their best works, but they were gracious to let us make the choices to meet our objectives. All the works in the exhibition are on loan to us by the Chinese artists. To the extent that this small exhibition is capable of doing, it attempts to present an overview of traditional painting in China today.

The exhibition is comprised of sixty-six works of art, mostly paintings executed in the traditional Chinese ink-and-brush style (occasionally with mixed media), but it also includes several sketches. Thirty-six painters are represented, many of them noted calligraphers and scholars as well. All of them are living artists, except for Li Kuchan who just died on June 11, 1983, at the age of eighty-six, after this exhibition was assembled. The paintings and sketches were mostly selected by myself at various stages for the exhibition, with suggestions made by Cahill and Sullivan; Chinese artists also participated in the selection by offering their opinions and suggestions, besides making their own works kept in their private collections accessible to us. Very few of the paintings have ever been seen or published outside China; the exceptions are ones that have been shown in Hong Kong and Japan. To our regret, many highly esteemed and worthwhile artists are not represented. Some of them could not be reached when I traveled in China to organize the show, or their best works were on display elsewhere and thus not available.

Members of the Chinese Artists' Association were most cooperative in giving us every freedom to select what we wanted, and went to much trouble to collect paintings by artists in various regions throughout China whose works we had asked for.

The big portrait of the historian Sima Qian by Shao Fei (no. 34), for instance, was recalled from an exhibition in a provincial museum to Beijing in time to be airfreighted to San Francisco, in response to Cahill's request for this particular painting, discussed at some length in his essay. It is to Cahill's credit that such artists as Yang Gang, Nie Ou, Peng Peiquan, Zhao Xiuhuan, Zeng Shanqing—all from Beijing and several of them members of the Beijing Painting Academy—came to be included in the exhibition, as he had seen their works in an exhibition while on a visit to China in 1981. The new trends and experiments of these painters, which he has discussed in his essay, add new dimensions to traditional Chinese painting and to this exhibition.

Because of Sullivan's suggestions, transmitted from Oxford, England where he had been during the time when I was organizing this show, I was introduced to the very interesting and innovative painter Wu Guanzhong in Beijing. His unique painting "Ruins of Gaochang [Turfan]" (no. 39) and three sketches (nos. 40, 41, 42) were added during my last trip to China in the spring of 1983. Having been trained in both China and France (like his internationally known friend Zhao Wuqi, who now lives in Paris), Wu Guanzhong displays a superlative synthesis of traditional Chinese methods—particularly his handling of fluid, calligraphic, "silk-thread" lines and use of dots (*dian*)—and Western elements, such as his cubistic composition and arbitrary use of colors for their own sake, regardless of descriptive function.

Yang Yanping was a name suggested by Sullivan and Cahill. Her sparse "Towering Mountain" (no. 53) illustrates the tendency among certain contemporary Chinese painters to abstract from nature and create images that are close to pure forms but are never entirely divorced from reality. The thin, tensile lines that delineate the rocks and trees, I was fascinated to learn, were drawn by the use of a compass, a technique that this artist has been experimenting with in her landscape, figure, and flower paintings.

In addition to the younger artists, I have chosen to include the well-known, veteran painters whose works are now considered more traditional—even conservative. In spite of their fame in China, Japan,

and Hong Kong, these established painters and pioneers of twentieth-century Chinese art remain relatively unknown to the American audience, and some even to specialists of Chinese painting in this country. The study of Chinese painting in America, after all, has so far focused on much earlier periods, with little regard to modern developments, unlike the study of Western art. And during those long years when China closed its doors to the outside world, who had access to the works of these artists, let alone the chance to do research on them?

In mounting this exhibition, I am also fulfilling a promise I made to some of those artists who were so helpful to me during my various trips to China—a promise to present their works to the outside world and to bring recognition to their art which they deserve after the long years of privation and isolation. While China as a nation is slowly emerging into the international world scene, Chinese artists today are searching for their place and identity not only in China's new society but also in the international art world.

Among the younger artists represented, those in their thirties and forties, I myself am particularly attracted to the landscape paintings of Li Huasheng, an artist who lives and works in Chongqing, Sichuan province. I came across his paintings in 1981 at the home of the Beijing artist Zhang Bu, who was then organizing a show to be displayed in Japan. The extremely individualistic, even quirky, style of Li Huasheng's landscapes caught my attention, and the fact that he was from the remote province of Sichuan in southwest China made the discovery even more interesting. (My travels in China in those days were largely confined to the big cities, except for visits to ancient archaeological sites mostly in the north that were the subjects of my graduate studies in ancient Chinese art history.) Subsequently, when assembling this exhibition in late 1982, I visited Li Huasheng in Chongqing and saw a great number of his paintings. He is a prolific and versatile painter. In his home I viewed works that were naive, whimsical, witty, and eccentric, painted in the free, sketchy "idea-writing" (*xieyi*) manner. The novel compositions were full of surprises. There were also monumental ink-monochrome landscapes painted with bold, vigorous

calligraphic brushwork in the abstract-expressionist style, which surpassed all such works that I had seen in their freedom, spontaneity, and sense of urgency. The infinite variety and the unique character of his paintings hint at a highly distilled and complex sensibility. The two paintings in this exhibition (nos. 19, 20) suggest the intricacy of his styles.

Choices in art are often a matter of personal taste. In my mind, Li Huasheng is perhaps the most original and interesting painter on the contemporary Chinese art scene. (Cahill and Sullivan acknowledge him to be among the innovative younger artists.) What are his sources—and where does he get his inspiration? The expensive art books produced in the West and in Japan are not readily obtainable by the Chinese artists. He has never traveled abroad, like many other Chinese artists, and has never heard of Picasso, whose style he sometimes resembles. He paints what he sees around him, he says. True enough—the thatched huts and the stubby trees that he depicts actually exist in the villages of Sichuan, as travelers to that region will attest. His depictions of the Yangzi Gorges with mountaintops full of dots (*dian*) and rocks defined by "axe-cut" (*fupi*) and "hemp-fiber" texture strokes actually evoke the tree-studded mountains and serrated rock forms peculiar to the Gorges. A journey I undertook down the Yangzi Gorges confirmed the fundamental realism of his landscapes. Li Huasheng's painting—almost all of them landscapes—appear to have very little outside artistic influence but rely upon his natural instincts.

Zhang Bu's painting is indicative of notable new directions. He experiments boldly with color, sometimes applying layers upon layers as in Western oil painting, although he uses Chinese ink and pigments. The hues of his "Winter Forest" (no. 56) in this exhibition, while demonstrating his highly painterly method, are more subdued than usual. His themes are often the remote landscapes of southwest China, such as Yunnan province, and other tropical regions. The colors are usually brilliant—mineral blue, glaring yellow, and loud pink—and there is often a strong regional, ethnic flavor in his paintings. Zhang Bu's works are worthy of our attention, and his innovations make a significant contribution to Chinese painting today. His recent

works, painted during a trip to Romania and exhibited at the Chinese Art Museum in April, 1983, reveal changes in his style—the colors now softer and more impressionistic. His pen-and-ink sketches (nos. 57, 58, 59) show masterly control of line, form, and color in dense compositions. They may be viewed as highly polished paintings rather than mere on-the-spot preparatory drawings. His paintings are based on these sketches and on memory—the method used by almost all Chinese artists, whose art is always a distillation of their experience.

Li Keran, the doyen of contemporary Chinese painters and the teacher of Zhang Bu and some other younger artists, once remarked that he had learned most of all from close observations of nature, even though his work was also influenced by the woodcuts of the German artist Kaethe Köllwitz. "I wish to create a realm close to nature," he said, "one that conveys a sense of atmosphere and embodies my ideas and feelings." He believes that once this realm has been depicted in a painting, the work of art will bring the viewer close to the actual scenery that inspired it and will arouse his emotional response. In an essay published in the inaugural issue of *Meishuyanjiu (Studies on Art)* in 1979, Li Keran emphasized the importance of tradition but also called for the courage "to create and discover new things—for our world today is not the same as that of the past. One should also learn and absorb from foreign art, to discover the different ideas of beauty held by different cultures". Li Keran paints a fresh and spontaneous world, in which nature and innocence prevail, as may be seen in the Guilin Li river scene in south China (no. 23), one of his favorite subjects. His two other paintings in the exhibition, "Laughing Monk" (no. 21), which he painted especially for us this year, and "Playfulness in Autumn" (no. 22), show the influence of his teacher Qi Baishi, especially in the rendering of the wisteria above the boys and water-buffaloes in the latter painting.

Most of my thoughts on China's recent revival of traditional art—particularly having to do with the older famous artists such as Li Keran, Liu Haisu, Guan Liang, Wu Zuoren, and Cheng Shifa—have been discussed in an earlier article published in *Portfolio* (April/May 1980), the result of two trips made to China in 1978 and 1979. In that article, I

briefly examined the background of modern Chinese art, which began in Shanghai in the late nineteenth century, following its opening as a treaty port for Western trade. Shanghai's lively cosmopolitan atmosphere and growing importance as an art market attracted a great number of artists. Many of them were drawn to the work of the "Yangzhou eccentrics" (*Yangzhou baguai*), a group of eighteenth-century painters who had reacted against orthodox styles by experimenting with bold and unconventional techniques. Some Yangzhou artists painted with fingernails—a technique seen in this exhibition in Zhou Changgu's "Camellia" (no. 62). Others chose vulgar and mundane subjects, or strayed from the normal course by introducing wit and surprise into their paintings. Fang Zengxian's "Zhong Kui" (no. 12), a demon-like figure that has inspired Chinese painters throughout the centuries, is portrayed with ambiguity and wit. The "Yangzhou eccentrics" tradition still seems to be quite alive, and is continuing to influence today's Chinese artists.

The "Shanghai school" (*Haipai*) of painting developed in time, and its followers—Ren Bonian and Wu Changshi, for example—are now generally acknowledged to be pioneers of the modern Chinese art movement. Their ideas revitalized Chinese painting at the turn of the century and extended to the art world of Beijing, where even Qi Baishi, probably China's best-known and most-liked modern painter, was to some extent influenced by Wu Changshi in his bold designs and use of colors.

The leading Shanghai artists represented in this exhibition include such well-known painters as Cheng Shifa, Guan Liang, Zhu Qizhan, Liu Haisu, Xie Zhiliu, Chen Peiqiu, and Lu Yanshao. In his two paintings on goldleaf paper, "Lichee" and "Begonia" (nos. 4, 5), Cheng shows the more traditional aspect of his art and his affinities with the "Shanghai school" in his decorative use of colors and stylized elegance. His reputation mainly rests on his figure paintings, however, exemplified by his monumental portrait of the historical figure "Ji Kang" (no. 7), which is discussed with much admiration by Cahill in his essay. I personally favor Cheng Shifa's landscapes, for example, his "Autumn Scene" (no. 6), dated 1981. In this, his juxtaposition of precise, linear details with richly suffused ink washes is

remarkable, combining the reticent and the exuberant, the explicit and the allusive. It is evocative of the eleventh-century monumental Chinese landscape tradition, recalling Guo Xi in its "crab-claw" trees and its compositional formula. The feeling of antiquity persists, but the idiom is contemporary.

Guan Liang, another major Shanghai artist, specializes in caricature-like figures taken from the Peking opera, historical tales, and folk legends (nos. 13, 14, 15). His style is unique and distinctive for its naiveté and comic flavor. Zhu Qizhan, the oldest artist represented—now ninety-one—paints landscapes and flowers in vibrant, captivating colors reminiscent of French impressionism (no. 66), having studied Western oil painting in Japan in his younger days. Western influence is also evident in the works of Liu Haisu, who is represented by a magnificent, ink-monochrome mountain landscape of "Huangshan" (no. 27), pervaded by drama and tension, and influenced by the German expressionists.

Liu Haisu, now eighty-seven years old and still very actively painting, was one of Shanghai's most vocal artists in the 1920s and 1930s. Along with the late Xu Beihong and other painters who had spent time in Europe, he returned to China fired with new ideas and introduced Western realism, impressionism, and post-impressionism to his homeland. He painted in oils but has now returned to traditional Chinese ink and brush. (A major retrospective of his works was held just recently in April and May, 1983, in Shanghai and then in Beijing.)

Wu Zuoren in Beijing, now acting director of the Chinese Artists' Association and a professor at the Central Art Academy, also studied in Paris during the 1920s. Best known for his images of camels, yaks, eagles, swans, and pandas, Wu usually paints in Chinese ink monochrome, occasionally enlivening his palette with touches of pale color. His paintings are rendered in pure ink washes without the delineation of contour, a technique called "boneless" painting (*mogu hua*). With deceptively simple means, he conveys a sense of the spatial recession and perspective that are key elements of Western realism, such as may be seen in his "Herding Camels in Gansu" (no. 43). His achievements are best

summed up by a Chinese critic who wrote: "In one brushstroke, Wu conjures up a thousand miles."

Much has occurred since 1979 in contemporary Chinese painting. Among the new trends I have been able to observe on subsequent trips made during 1981 to 1983 is a renewed interest in descriptive realism, particularly the meticulous method of detailed drawing filled with decorative colors known as *gongbi hua*. This style is exemplified by Zhao Xiuhuan's flower paintings (nos. 60, 61). For a long time, this tradition had been downgraded and neglected in Chinese art history—an attitude that may be attributed to the rise of "literati" painting (*wenren hua*) in the latter half of the eleventh century.

Advocated by a coterie of scholars, many of them poets, the "literati" aesthetic theory stated that painting should not simply be a recording of observed nature and visual truthfulness, but should, instead, express the artist's inner personality. It should capture the spirit or essence of the things depicted, which could be achieved through the calligraphic potential of the Chinese brush. Painting became a highly personal creative act whose sole function was self-expression. This subjective and individualistic theory was, in effect, a radical reaction against descriptive realism. Nearly a thousand years later, well into this century, the "literati" theory still profoundly influenced the development of Chinese painting. It was denounced by the new socialist regime in the early days of the People's Republic and during the Cultural Revolution, for being elitist and esoteric. This individualistic conception of art, however, has since re-emerged. As Ya Ming said to me in 1978, "Painting is to express emotion. As soon as the artist is moved by a certain feeling, his hand must be ready to put brush to paper." The new artistic freedom and personal vision permitted in China today have enriched contemporary Chinese painting, as evident in the wide spectrum of styles and themes seen in this exhibition.

In the hands of the young talented artist Zhao Xiuhuan, the meticulous method of descriptive realism (*gongbi hua*) has attained a new stature, and Chinese critics today are giving the style serious attention. Far from being mindless documentation of visual appearance or mere verisimilitude, Zhao

Xiuhuan's paintings evince not only technical excellence but also an indefinable spiritual—almost ethereal—quality. This is particularly true of her huge painting "Mountain Stream" (no. 61), filled with bluish and lavender foliage and blossoms. The mood is lyrical and melancholy, imbued with an enigmatic aura heightened by the surrealistic glow that seems to emanate from within the painting. This strong feeling of mystery also permeates Yang Gang's figure painting "Dawn" (no. 48), depicting the cowherd in rear view, half-concealed, tending the animals in the early morning. Subdued bluish-grey tones add to the mystifying ambiance. It is as if there is some hidden message of escapism or negation in the rear-view depictions of the human figure that Yang Gang frequently employs—such as in his sketches (nos. 49, 50, 51).

Descriptive realism of a different tradition, called the "ink-outline" (*baimiao*) method, is applied with dexterity in Huang Yongyu's "Lotuses" (no. 17), drawn with sinuous, continuous "silk-thread" lines that describe the lotus forms simply and plainly, without colors. The impression is one of unobtrusive blandness (*dan*)—a quality that Chinese critics have always praised—and of elegance. This more traditional painting is rarely seen among the works of Huang Yongyu, who is better known for his Western-influenced landscapes and various stylistic experiments. A versatile artist, he is often full of surprises.

To many viewers of this exhibition, the most striking feature of the contemporary Chinese paintings on display may be the tendency towards abstraction—the formalistic approach that makes some of these paintings "contemporary" and even "modernist" in flavor, despite their infusions of tradition. Wu Guanzhong epitomizes this new trend and, because of his Western training, one is inclined to ascribe this feature to Western influences.

Yet similar directions—though not as extreme—are also visible in the works of the Beijing artists Cui Zifan (nos. 8, 9), Yang Yanping (no. 53), as already mentioned, and Peng Peiquan. Peng's more recent painting of 1982, "New Rain" (no. 32), is a densely textured pictorial surface, characterized by a remarkable structural interplay of abstracted, abbrevi-

ated forms and tactile calligraphic brushwork. Elsewhere in China, artists are experimenting with pure form and color. The "Yangzi Gorges" (no. 28) of Liu Lun, a Guangzhou (Canton) painter, for example, is a scene of tranquility, rendered in areas of subdued, pale colors in which the most realistic features are the boats passing through the Gorges. It contrasts sharply with the same subject depicted by Lu Yanshao in his long handscroll (no. 29), with its elements of descriptive realism, and the expressionistic, turbulent scene of Ya Ming (no. 47). Zhou Shaohua, of Wuhan, paints a mountain snow scene (no. 63) based largely on the abstract, expressive qualities of brushwork, and a figure scene (no. 64) in a rocky landscape composed of suggestive, geometric forms.

These artists have never traveled to the West, as far as I know. But the impact of their masters—some of whom were very much influenced by Western art—and the infiltration of Japanese art (which gave rise to the "Lingnan school" represented by Guan Shanyue's landscape, no. 16 in this exhibition) no doubt stimulated the new trend toward a "contemporary" style of painting. Form-for-form's sake or art-for-art's sake is a recurring notion, independent of any social function, as suggested by the new trend toward abstractions and pure forms.

One is reminded, at the same time, of the very beginnings of artistic creation in China: the semi-abstract, semi-figurative images that decorate Neolithic pottery vessels of four thousand years ago, the recent archaelogical discovery of stick-like figures painted in the ancient caves of Yunnan, and the designs and motifs that adorn the Shang and Zhou bronze ritual vessels from about the seventeenth to the third century B.C. (These were exhibited in the magnificent show entitled *The Great Bronze Age of China* that toured the United States from 1980 to 1981.) Indeed, scholarly disputes have continued to this day over the issue of whether the bronze motifs—which sometimes hint at animal, zoomorphic creatures—were pure abstractions with no representational function, or if they were images or abstractions of images conceived with a symbolic or religious meaning. Does form follow function or is it form for its own sake? The arguments over these ancient Chinese bronzes began as far

back as 1968 with a momentous exhibition, *Ritual Vessels of Bronze Age China,* mounted at the Asia House Gallery (now the Asia Society Gallery) in New York City.

I think it is appropriate to sum up this mini-survey of contemporary Chinese painting with my concluding remarks in an essay on *The Chinese Exhibition,* that mammoth survey of Chinese art history based on recent discoveries of archaeological artifacts that came to this country in 1974. (The piece appeared in *Art in America,* November-December 1974): "A historical continuity . . . may be recognized as old forms and themes are adapted and transformed in new contexts, and invention and tradition are reconciled in the evolution of stylistic trends." This is true of contemporary Chinese painting—and indeed it is true of Chinese art for all periods.

Flower, Bird, and Figure Painting In China Today

James Cahill

One of the striking features of traditional Chinese painting, and one of the things everybody knows about it, is the dominance within it of landscape themes. Old Chinese books on painting recognized three major areas of subject matter: figures (including religious images), birds and flowers and animals (with a sub-category of ink-monochrome paintings of bamboo, blossoming plum, orchids, and other "scholarly" themes), and landscapes. Of these, landscape occupied the forefront for a long period from the tenth century to the early eighteenth, engaging the creative energies of most of the best artists over that time. It came to prominence again in the twentieth century, in the hands of such notable masters as Qi Baishi, Fu Baoshi, and Huang Binhong. Most of the best-known Chinese painters living and working outside China in recent decades have been primarily landscapists—such artists as Wang Jiqian, Chen Qikuan, Liu Guosong, and the late Zhang Daqian. Visitors to the present exhibition, moreover, will notice immediately that landscapes greatly outnumber the other subject categories. It would be easy to conclude, then, that Chinese artists in the People's Republic, released from the oppressive official policy of the Cultural Revolution and Jiang Qing years (1966-1976), which regarded landscape painting as neutral at best and intolerably elitist at worst, have simply gone back to where they left off. But the situation is not so simple as that.

For one thing, the dominance of landscape in Chinese painting did not continue unbroken through recent centuries. On the contrary, with the deaths in the early eighteenth century, all within less than a decade, of the three leading landscapists of the time (Wang Hui, Wang Yuanqi, Shitao), landscape slipped from its position of supremacy and, on the whole, was practiced only on a relatively low, unimaginative level after that. The "Strange Masters of Yangzhou" in the eighteenth century and the leading Shanghai artists of the nineteenth painted figures, portraits, birds and animals, flowers and plants—subjects that were all more in demand than landscape among their primarily merchant-class patrons and customers. When the People's Republic authorities more recently associated landscape painting with China's intellectual elite and other subjects with a more popular audience, then, they were only following a well-established tradition of thought.

Viewed in this perspective, the reflorescence of landscape painting in the 1930s might be interpreted more as breaking a large historical trend than as conforming to one. Future art historians may well come to regard this reflorescence and its aftermath, the landscape painting of the pre-Cultural Revolution years and of today, as an episode within a larger non-landscape continuity. To suggest this is not to belittle the achievements of the contemporary Chinese landscapists, who are represented by excellent works in this exhibition. Any movement that includes such diverse and innovative masters as Wu Guanzhong, Li Huasheng, and Yang Yanping is certainly not stagnating. I mean only to hazard the observation that the non-landscape continuity within Chinese painting, so strong in recent centuries, may very well be returning to the forefront. Listing a few of the artists of the past who make up that non-landscape continuity will define the tradition that underlies the developments we are concerned with in contemporary painting, and will also indicate its strength: Xu Wei in the sixteenth century; Chen Hongshou and Bada Shanren in the seventeenth; the Yangzhou masters such as Hua Yan and Jin Nong and others in the eighteenth; the "Shanghai school" in the nineteenth, with Ren Xiong and Ren Bonian as the leading specialists in figures, Zhao Zhiqian and Xugu in flowers and Wu Changshi, Qi Baishi, Xu Beihong, Pan Tianshou and many others in the twentieth. All these artists concentrated their main energies in areas other than landscape, and echoes and influences of all of them provide much of the richness of style and imagery to be seen in Chinese painting today.

Shanghai has remained the center of Chinese bird-and-flower painting into this century, and the tradition continues strongly there. Four of the older bird-and-flower specialists working in the Shanghai Painting Academy—Tang Yun, Xie Zhiliu, Chen Peiqiu and Cheng Shifa (the last two in fact only middle-aged, and Cheng better known for his figures)—are well represented in this exhibition. They make up, on the whole, a more traditional trend. But Cheng can invent new ways of portraying flowers with the same technical brilliance he displays in his figure painting, and Xie Zhiliu's painting "Peony" (no. 45) proves that an artist in his seventies can still move us with a fresh solution to the old problem of how to make seemingly spontaneous splashes of ink and color "read" as images from nature. Xie's ink and color draw one's gaze into their depths in a way that overcomes the flat-surface limitations of much recent Chinese flower painting.

Works by other artists who specialize in flowers, mostly younger, working in Shanghai, Beijing, and elsewhere, similarly exploit the richness of deep ink and color that the Chinese materials and techniques allow, although they seldom achieve quite the nuances that Xie Zhiliu can call on at this late point in his long career. Fang Jizhong in Xi'an evokes the sixteenth-century master Xu Wei in his wet-splashed, ink-monochrome "Lotuses" (no. 10). Xiao Shufang's "Everlasting Spring" (no. 44) makes a small space glow with strokes of saturated color that may remind the Western viewer of Emil Nolde's watercolors. Cui Zifan, an older artist from Shandong now working in Beijing, applying the same soot-black ink and luminous colors as the others in blunt brushstrokes derived from the style of Qi Baishi, takes us a long step beyond Qi's painting, into bold near-abstractions (nos. 8, 9). Perhaps as a kind of reaction to the dominance of this wet manner, Huang Yongyu draws his "Lotuses" (no. 17) in a precise, classical ink line (*baimiao*) that seems to depend on woodblock prints, of which Huang is also a master. All these are promising directions, drawing productively on older flower-and-plant painting without repeating it.

China has always venerated its aged artists, and praised young ones, if at all, for precocious mastery of their elders' styles. Originality and innovation were supposed to arrive late, after long periods of assimilation and slow change. One could scarcely expect this attitude to persist in today's China, and it has not. Old painters are still respected, but the young are more inclined to go their own ways. When, in the autumn of 1981, I visited a large joint exhibition of the Shanghai and Beijing Painting Academies (about one hundred paintings, one each by that many artists, old and young), and listened to our guide identify each painter by age, sex, and background, I was persuaded that one could make good guesses at the ages of the artists from their styles. The older masters, understandably, are inclined to return to their familiar styles of the 1950s and 1960s;

those of middle age attempt relatively cautious departures; but when one comes upon a painting that displays a strikingly new style, it usually turns out to be the work of a young artist. One can observe these young painters, who grew up in difficult times, with sympathy and admiration as they try to mark out independent positions on the great, over-crowded ground of *guohua* or "traditional painting". They fail sometimes, but even their failures are likely to be more interesting than the repetitive works of some of their elders, and they also score impressive successes, as this exhibition amply demonstrates.

Within the Central Art Academy in Beijing, Wu Zuoren and the late Li Kuchan, who died just recently after this exhibition was assembled, represent the older generation. Wu continues to paint the evocative scenes of animals that are his specialty (no. 43), and Li the slightly bizarre birds and plants that are his (nos. 24, 25). It is reassuring to see these distinguished painters extending the lineages of the earlier twentieth-century masters Xu Beihong and Qi Baishi into the present, while practicing the individual manners on which their reputations are based.

The most original work in flower-and-plant painting in China today, in my (admittedly personal) view, is being done by two younger artists of the Beijing Painting Academy, Zhao Xiuhuan and Peng Peiquan. Zhao explores a heavily-colored, strongly decorative, somewhat romantic mode—a kind of painting that Chinese artists have generally avoided over the centuries, partly out of fear of censure by severe-minded critics who regarded it as too appealing, too accessible to "commonplace, vulgar people". The eleventh-century critic Mi Fu would doubtless have pronounced Zhao's paintings, as he did the early Song master Zhao Chang's, to be "suitable for hanging on the wall when you are marrying off a daughter". And the fact that the artist is a woman would have confirmed his judgment.

But attitudes toward "commonplace people" and daughters have changed in China, and our initial hesitation in admiring Zhao's paintings are likely to be of another kind: we may see them as following Japanese models too closely. Her style is indeed influenced by Japanese painting, as she is quick to acknowledge, but its roots are also in a long-neglected Chinese tradition of flower painting that featured decorative forms and heavy colors, a tradition practiced by specialist artists in the Song, Yuan, and Ming dynasties. If old paintings of that kind are not commonly seen in China today, it is not because they were not painted, or not popular, but because collectors—affected again by the strongly expressed scorn of critics—did not preserve many of them. They can be seen in large numbers in Japan, where a more open love of decorative beauty ensured for them a continuous appreciation and preservation ever since they were imported from China centuries ago. In fact, some of the innovations of younger Chinese artists today depend in part, like Zhao's, on a negation of old elitist biases against popular styles. (We will note later the same phenomenon in figure painting.) If we can accept this new attitude as premise, relaxing our own (differently based) biases against the same qualities of direct visual appeal, we will be able to enjoy Zhao Xiuhuan's works for their cool, subtle portrayals of running water and lichen-covered rocks, and their harmonies of blue, green, and lavender in the leafage and blossoms of her flowering plants (nos. 60, 61).

Peng Peiquan's flower paintings offer visual pleasures of another, although not unrelated, kind. I can recall my first reaction, at the 1981 exhibition, to his 1980 *"Wan Feng"* or "Evening Wind" (no. 33): here is an artist who has, somewhat surprisingly, created a strikingly new style within the much-worked-over lineage that extends from Zhao Zhiqian in the nineteenth century through Wu Changshi in the early twentieth. Peng's compositions may follow those models, loosely, but the disciplined manner of brushwork-abstraction out of which he builds his complex formal structures, and the consummate blending of ink-wash and pale, cool colors, are entirely his own. If we try to define the strengths of Zhao Zhiqian's works and the best of Wu Changshi's—spatial clarity within densely interwoven areas, achieved through closely calculated tonal gradations; a limited but supple repertory of brushstroke types; a sense of vitality and growth in the plants, transmitted through unflagging but controlled energy in the execution of the painting—we will find them also in Peng's. The capacity of the Chinese tradition to sustain creative transformation is no-

where better demonstrated; if this tradition is to be continuously rejuvenated, it is through such works as these. Better yet, Peng does not seem to be standing still, even after such achievements: his 1982 "*Xin Yu*" or "New Rain" (no. 32), at the same time that it describes the rain-drenched narcissuses and rock, carries further the abstracting power of his stuttering, suffusing line. As in the works of Zhao Zhiqian, all brusque, calligraphic gestures are avoided, and ink and color are laid on with the care of someone carving in wood or engraving in stone.

The figure painting being done in China today exhibits more or less the same pattern, a continuation of 1950s-60s and earlier styles among the older artists, and innovation among some of the younger. Li Keran, probably the best-known painter now active in China, depicts his favorite subjects—herdboys with water buffaloes (no. 22), scholar-poets from the past, or religious figures in the Chan Buddhist tradition (no. 21)—with seemingly undiminished enthusiasm and vigor. A host of popular painters follow him, too often with one eye on the foreign market. Guan Liang in Shanghai, now eighty-three, continues to celebrate the Chinese theater in delightfully spirited, sketchy pictures of its actresses and actors, in their colorful costumes and painted faces, playing their dramatic roles (no. 14). Guan Liang's paintings, in calligraphic drawing as well as in subject matter, could be taken (as could Li Keran's) as metaphors for the position he represents in contemporary Chinese painting: they are re-enactments of traditional Chinese culture, affirming that old motifs and values persist even after terrible cultural wrenches. As such, they are welcome; at a time when cultural continuities are imperiled, any displays of them on this level of distinction must be regarded as positive manifestations.

The heavily politicized, artistically low-level figure art of the Cultural Revolution years and after, from which aesthetic or "formalistic" considerations were ruled out, lies as a heavy weight on Chinese figure painting today: how to deal with it? For those older artists whose styles were fully formed before it happened, and who could escape being drawn into it more than peripherally, it is easy enough now to ignore it and go back to their earlier subjects and

styles. Cheng Shifa, who at sixty-two is the leading figure master in Shanghai and probably still the most accomplished and versatile figure painter in China today, is in a different position. For him, the period of the 1950s and early 1960s was the time when he achieved his first great acclaim, and when his distinctive style took form. His subjects of that period—children of minority peoples tending animals, illustrations to such stories as Lu Xun's *Ah Q*—belonged more to the new society than to the old. His works differed from the propagandistic figure art of those years not in their subjects but in their technical brilliance, their sophisticated use of old styles (especially that of Chen Hongshou, whom he admires and understands profoundly) and their originality—his may be the first truly original figure style in Chinese painting since Ren Bonian.

The most admirable qualities of Cheng's paintings of the 1950s and 1960s, their combination of wiry but descriptively telling line drawing with bold splashes of ink in compositions of unfailing inventiveness, were exactly what got them condemned by Cultural Revolution arbiters as "formalistic". Ironically, this was just about the time when some critics and viewers in the United States, no more attentive to the artistic excellence of the paintings and no less ruled by critical dogma—even though theirs urged them in the opposite direction from that of the Chinese—were pronouncing Cheng's paintings too popular, or too "sweet". Now Cheng is popular again in China—perhaps too much so for his own good. The ups and downs of critical response can create more problems than opportunities for a painter.

Cheng Shifa's great return to popularity in recent years is, as he recognizes clearly himself, his most pressing danger: the more he accedes to the demand for his familiar images of rosy-cheeked children and charming animals, the less he can devote his energies to his continuing development as an independent artist. Nonetheless, he manages to stay well ahead of his many imitators by painting, in addition to the works that are imitated, others that are less subservient to popular expectations, and that consequently remain little-known in the midst of all the publications of his works. Some of these less popularly intended paintings portray historical

figures in unfamiliar but strongly humanized images, as if Cheng were bringing the living personages before our eyes. An excellent example, painted in 1980, is his powerful, unsentimental portrait of Ji Kang, one of the "Seven Sages of the Bamboo Grove" who lived in the third century and was condemned to death for offending an imperial prince; we see him playing the lute (*qin*) as he awaits execution (no. 7). The strong composition is based on triangular shapes in which massiveness—even monumentality—of form is reconciled with sensitivity of drawing in a way that can scarcely be matched in Chinese figure painting today.

A similar monumentality is achieved in a less traditional idiom by Shao Fei, a young painter in the Beijing Painting Academy, in her imaginary portrait of the early Han historian Sima Qian, author of China's first dynastic history, the *Shi Ji*. Painted on a tough, heavy paper that could withstand repeated applications of ink and color (partly opaque, like gouache), its layers are overlaid like glazes in oil painting. It presents the great historian as a dark, brooding figure in a style that recalls stone sculptures, or ink rubbings from inscriptions engraved in stone, more than it does the traditional materials and techniques of Chinese painting. Incorporating a written text (in this case, passages from the *Shi Ji*) into the painting is not an entirely new idea— inscriptions had been integrated compositionally with the pictorial elements in works by the Yangzhou masters of the eighteenth century, and Zhao Wuqi (a Chinese artist now living in Paris) and others in the twentieth century have used half-concealed writing in their paintings. But Shao Fei's treatment of the painting surface as richly textured engraved stone is an effective, original idea, and makes one want to see more of her work.

Representing historical figures in painting in the People's Republic is not simply a matter of making homages to famous people of the past; most of the time, the artist is commenting on some personage or situation in the present, and his underlying meaning will be understood by his knowing audience. The portraits of Ji Kang and Sima Qian by Cheng Shifa and Shao Fei presumably carry some such contemporary application, which will not be apparent to non-Chinese viewers. But these are paintings

that can stand on their own as powerful works of art, not merely as conveyors of political messages. While they grow out of the overtly ideological figure modes of the earlier decades, they transcend them —and that is the key to some of the best of the new Chinese painting. Where many of their contemporaries have responded to the new freedom from constraints by rejecting altogether the recent heritage of didactic figure painting, some of the younger artists, who grew up with it and doubtless still feel a strong emotional attachment to it, are raising it to the level of good art, replacing its blatant messages with more subtle ideas and its magazine-illustration manner with stronger, more original styles. It is a project fascinating to observe, especially since it seems to parallel the pursuit by Chinese painters in earlier centuries of solutions to similar problems—how to reconcile inner motivation with outer circumstance, or popular appeal with high quality.

The ethnic minorities of China and its neighbors have been subjects favored by artists of the People's Republic and also approved by official policy, since pictures of them express the desired attitude of tolerance by the Han Chinese majority for local or ethnic dress and customs. Cheng Shifa portrays the Dai people of south and southwest China; artists of the Beijing Painting Academy and the Central Art Academy in Beijing typically portray the peoples of Xinjiang, Mongolia, and Tibet, places they visit regularly on study-trips. Zeng Shanqing, who teaches at the Central Art Academy, conveys his perceptions of the harsh existence of Tibetan cowherds in a painting (no. 55) that skillfully uses the texture of the paper and a spatter technique to render snowfall. It is this kind of sympathetic penetration of unfamiliar ways of life that gives depth to the best pictures of this genre by today's Chinese artists. Zeng's figures, in their stolid dignity, are nearly as monumental as Shao Fei's Sima Qian.

Yang Gang, a young artist who spent some time in Mongolia and now works in the Beijing Painting Academy, captures the precise character of his subjects—Mongolian wrestlers with their attendants and a crowd of admirers (no. 52)—with a mastery of draftsmanship that recalls the best paintings of early twentieth-century European artists, and which

would be hard to match there today. His painting titled "Dawn" (no. 48), depicting a cowherd and cattle in the rain, translates the same images into a highly finished line-and-color manner, with harmonies of grey-brown and blue-purple enhanced by flecks of gold. Like Zhao Xiuhuan's flower images, this one betrays some influence from recent Japanese painting; today's young Chinese artists are taking what is useful to them from a diversity of sources in their efforts to revitalize their own tradition.

My own favorite among the younger figure specialists in China is Nie Ou, a woman painter only thirty-five years of age, who graduated from the Central Art Academy and now works in the Beijing Painting Academy. She perhaps best exemplifies the phenomenon noted above, a tendency among some younger artists to continue or recall the ideologically-charged figure painting of the previous decades, while raising it to a higher qualitative level by making it subtler in conception and more original in style. The figure painting of the first three decades of the People's Republic, however simplistic its messages and homogenized its styles, represented —and no doubt still represents, for many who lived through those years—a humanizing of the Chinese painting tradition. This was a tradition that had too often, in its past, seemed remote from the concerns of ordinary people. Confucian-minded theorists might argue that Chinese painting had always been imbued with human qualities, and their argument is true enough, in the special sense that painting was traditionally considered to express or transmit the artist's mind and feelings. But for most Chinese, this was a rather esoteric doctrine, and it did not make the paintings appeal to more than a small segment of China's population. Painting under the People's Republic aimed at humanizing the tradition in a far more radical way—and succeeded, although too often at the expense of artistic values. And it is this human quality that artists like Nie Ou want to preserve, along with whatever suits their purpose from the older tradition.

It may be significant that it is a woman who has accomplished this, and that a high proportion of the other innovative artists in this exhibition—Shao Fei, Zhao Xiuhuan, Yang Yanping, and others—are also women. Works by women artists in traditional China tended to treat properly "feminine" subjects such as birds and flowers, or orchids; they conformed to what was expected more than they expressed deep feelings. The reason, one hastens to add, was social pressure; any attempt to break the confines of "polite" women's art would have been snuffed out quickly, and it doubtless was, many times. Now, happily, the situation has changed: perhaps the new sensibility is one to which women artists are particularly adapted. If they can "hold up half the sky", why not half of art—and not the lesser half? This would indeed be a revolution, in more than a merely rhetorical sense, and it may be happening.

Revolutions aside, Nie Ou portrays her daily-life subjects with a tenderness that has not been a conspicuous trait of Chinese figure painting, at least not since the Song dynasty. Her style, with its pale ink tones and sensitive brushstrokes, is ideally suited to that end: the representations are as unassertive, and as simply honest, as the people represented. She paints ordinary Chinese people, with an eye to the grace of their movements and their unfailing good humor. Seen beside these, the figures painted by some of her better-known contemporaries—posturing males baring their teeth in stereotyped smiles—seem flashy and superficial. Her painting "Lu Qi" or "Dew" (no. 31), represents young people bringing lunch to workers, or farmers in the fields, and catches something of their physical relief as they put down their loads. This air of absorption in the task is broken by the ambiguously expressive, sideward gaze of the girl, the only one of the five figures who faces outward. In some of her other works, Nie Ou presents her basic theme of close, warm human relationships in depictions of peasant couples and families. Her style is sometimes bolder than seen here, striking however the same nice balance between characterizing and abstracting brushwork that one can admire in Cheng Shifa's paintings.

Other young figure specialists in Beijing, Shanghai, and elsewhere are moving in similar directions but are not represented in this exhibition. Many of their works would probably be judged too emotionally appealing or too obvious to please Western audi-

ences, whose level of tolerance for serious figure painting tends to be low. A recurring perception, during my three-month stay in China last autumn, was that some of what we initially perceive to be China's problems can be turned around and recognized as our own. Recent Chinese figure painting is, I believe, a case of that kind. From the 1950s into the 1970s, many of us smiled and sniffed at the naiveté of most of the painting published in the Chinese magazines. That much of it was facile, sweet, even kitschy, is certainly true. But it is equally true that American critics and museum-goers were likely to respond in the same way even to paintings that were *not* facile or kitschy. When, for instance, several of Cheng Shifa's figure paintings were shown in an exhibition at the University Art Museum in Berkeley in 1974, local newspaper critics put them down as "good greeting-card material" or as "clinical examples of what can happen when politics or commercialism dictates the policies of art". Only one critic remarked, more perceptively, "I suspect that these artists' true ideal is a kind of sweetness and innocence . . . "

Only slightly later, an exhibition was shown at the same museum of pastiche paintings by a French artist who cleverly placed images from the ideological art of China—Chairman Mao, factory workers, etc.—in incongruous French settings such as the Arc de Triomphe. These were considered acceptable and exhibitable, where the Chinese paintings that were played upon were not. And yet the French paintings were no less shallow, no higher in quality, no more "honest"; they were only conforming to a fashionable French radical-chic mode, like Godard movies. The unacceptable Chinese paintings of those years included, in fact, along with the kitsch and the banalities, some deeply felt and deeply moving, artistically excellent works, which we were prevented from appreciating by the narrowness of our own vision. We had been conditioned by our most influential critics and artists to believe that serious figure painting was quite dead, and could be revived only occasionally in parodistic, strongly distorted, or otherwise dehumanized form. Comic-strip style or subtly mocking photo-realism was acceptable—some twist of style that assured us that the artist was not really trying to move our feelings or involve us in a truly empathic response, that the picture was not serious. Chinese artists mean what they paint, and that is part of the difficulty they pose for us. We tend to doubt authenticity in others to the degree that we find it hard to achieve or preserve in ourselves.

My argument is not that everything painted in China then or today—or even everything in this exhibition—achieves authenticity in this sense, but only that many of the paintings do, and that we must try to recognize it when it occurs in the midst of a larger output of repetitive and commercialized paintings. The Chinese painting tradition has too much momentum, and is being carried on today by too many serious and highly accomplished painters, to allow us to pass it off on the basis of its failures as an unworthy continuation of its glorious past.

All of the above is speculative, personal, perhaps biased. Attempts to take long art-historical views of present phenomena are always perilous, having too often turned out to have been foolish. This exhibition gives viewers the opportunity to form their own judgments, choose their own favorites, and make their own conjectures about which tendencies will prevail and what will happen next in Chinese painting.

Chinese Painting Today: Traditional in Style, Modern in Feeling

Michael Sullivan

One of the first things that is likely to strike the visitor to this exhibition is the wide range of styles and techniques the painters have used. To people accustomed to thinking of Chinese painting in traditional terms, some of these pictures will come as a surprise. To understand what these painters have achieved, we need to ask ourselves: what is the tradition out of which they have sprung? What have they preserved of it, what rejected, what added? And above all, why are so many of them no longer content to go on practicing this beautiful and expressive language in the manner of their forefathers of Ming and Qing?

Chinese painting is at heart the language of the brush: in the beginning was the brushstroke. The brushstroke might be fine, delicate, controlled, in itself descriptive of form rather than expressive: this is *gongbi hua* (literally "craftsman-brush painting"); or it is expressive of the artist's ideas and feelings (*xieyi hua*). Between the two extremes of descriptive and expressive brushwork lies a wide range in the function and quality of line and ink wash. In traditional Chinese painting (*guohua*) color is generally added afterwards, as a kind of tinting to achieve verisimilitude such as we find in the watercolors of Dürer, for example—not as a form of expression in its own right, still less as a key element in the composition.

In *guohua*, rocks, trees, mountains, men and houses have been conventionalized through centuries of development which were eventually codified in artists' handbooks such as *The Painting Manual of the Mustard Seed Garden (Jieziyuan huazhuan)*, 1679. The subject matter is restricted to well-established, even hackneyed, themes in the natural world, with the result that it often needs the inscription to tell us just what the artist had in mind when he painted this well-known theme, and so give it interest to the viewer.

Almost all traditional Chinese paintings are generalizations, distillations of accumulated experience rather than responses to particular experience. The ideal is to make a statement that is eternally true rather than to record what is transient or accidental. The artist's attitude is one of reflectiveness, of detachment from objects, hinting through the beauty

and harmony of nature at the metaphysical truth that lies behind the visible forms. This traditional art was lyrical, elitist, unfailingly good-mannered; the worst crime was vulgarity. Great masters such as Qi Baishi, Huang Binhong and Fu Baoshi carried it almost unchanged well into the twentieth century. The death of Pan Tianshou in 1971, the effect of persecution by the "Gang of Four", might be taken as symbolizing the end of its long history of unbroken development.

No chronicle of Chinese cultural life since 1949, or indeed since 1900, can fail to take into account the turbulent state of China in modern times. Although the pictures in this exhibition have nearly all been painted in the last six years, the artists all lived through those decades of stress and distress which began in 1957, when Mao repudiated the Hundred Flowers movement. Many of them were branded "rightists", and so forbidden for the next twenty years to do any creative work of their own choosing. During the Cultural Revolution nearly all the artists represented in this exhibition became "non-persons", sent down to the country to labor in the fields: this was the period when, as Ya Ming later wryly remarked, he and Huang Yongyu belonged to the "Dung Basket" school of painting.

This is not the place to enlarge upon their suffering, which makes painful reading. It is only to ask how, when all art except the most rigidly doctrinaire was attacked, suppressed, or deliberately destroyed, these men and women survived, and were able upon their release in 1978–79 to turn their backs on the immediate past, pick up the traces, and carry on. This was indeed a triumph of the human spirit. Yet much was lost. With the art schools closed, with artists either forbidden to paint or required to turn out huge, lifeless pictures for hotels and public buildings, the vital thread of continuity with the past was broken. For the older artists who had matured before 1957 it was not impossible to start again, to remember. They are the bridge across the chasm of the wasted years. Without their training, their memories, almost all would be lost but the art of the museums. But for the young, who had received little education during the 1960s and 70s, and almost all of it hostile to tradition, there was no past, no thread to pick up. This partly explains the lack of

interest that so many younger painters in China today show in traditional art and their eagerness for anything new.

The youngest painter represented in this exhibition is Shao Fei, born in 1954; the oldest is Zhu Qizhan at ninety-one. Many are in their sixties and seventies. Yet even the most traditional of their works are full of vitality and freshness which seems to challenge the critics who say that traditional Chinese painting is a dying language. Nevertheless, we must ask how "contemporary" they are. Could any of them, for example, have been painted sixty years ago? Yes, a few: Tang Yun's "Squirrel" (no. 38), the flowers of Chen Peiqiu (nos. 1, 2) and Zhu Peijun (no. 65). Even Li Kuchan's "Vegetables" (no. 25) shows little significant change since Zhao Zhiqian and Wu Changshi, who with a new boldness of brushwork and color, brought Chinese bird-and-flower painting into the twentieth century. This testifies less to the originality of these painters—never a prime value in Chinese art—than to the strength of the tradition, carried by its own momentum through the profound changes that are taking place in Chinese social and cultural life.

If the tradition is so vital still, why change it? Why even reject it as so many are doing in favor of an art based on Western techniques and aesthetics? The truth is that for all its vitality, its subtlety, its rich history, traditional painting has limitations that are the product of its own strength. For there are emotions and visual experiences that up till very recent times *guohua* has never even attempted to convey. Tied to a repertoire of traditional rural landscapes, birds, flowers, bamboo, and certain edifying or at least agreeable and charming figure subjects, it simply did not touch on many things that might be the province of art. What about the types of landscape, for instance, for which there were no conventions in the repertory, such as deserts, and the wild places where no scholar ever trod; the shape and character of the city, the canals, roofs and white damp-stained walls of Suzhou; the life of the common people in all its complexity, from the humorous to the tragic?

But to break free from the pictorial conventions without violating the language was not easy. In the

1930s students set to paint a crowded street asked their teacher for photographs of people that they could copy into their pictures, for the camera had already created two-dimensional images for them. As late as 1964 the landscape painter Qian Songyan could speak of going to Huangshan, not to draw rocks as he saw them, but to "check his *cun*" to make sure that his repertoire of conventional texture strokes (*cun*) matched the actual rocks. It did not occur to him, working as he was within the *guohua* tradition, to abandon his *cun* and paint what he saw.

While stereotypes fitted well with the propaganda art of the 1950s and 1960s, when artists could buy new manuals showing the correct way to paint a heroic People's Liberation Army man, a corrupt Guomindang official, a leering American capitalist, they were no use when artists began to reject this whole approach to painting and to attempt, with eyes unclouded by convention or ideology, to paint the real world. An important aspect of the great scholarly art of the Ming and Qing dynasties involved painting "in the manner of" (*fang*) the old masters, of whose styles the painter acquired an encyclopedic knowledge. Today one paints "in the manner of" only for study purposes, and there are few paintings in this exhibition in which the stylistic debt to an old master is obvious, none in which it is declared in the inscription. Young painters know little of art history. Who is to say, for instance, whether Li Huasheng's apparent flouting of conventions (nos. 19, 20) is due to a deliberate defiance of them, or merely to ignorance of them? Perhaps, except for the very strongest creative personalities, such ignorance is the best road to freedom.

Gone today is much of the elitism of the old scholarly tradition, and with it the literary and philosophical shoring up through the inscription which enriched and gave point to the conventional images. Now more and more must the painting stand by itself, as a purely visual appeal to the emotions. This has little or nothing to do with the self-expression which conservative critics in China are constantly attacking. No true artist, in China or anywhere else, is primarily concerned with expressing himself or herself. Their concern is with the direct and sincere response to experience. For this, *The Mustard Seed Garden* is no help. This creates new problems.

For the language of the Chinese brush by its very nature tempts the artist to conventionalize. Why does a truck in a traditional landscape look out of place, a steamboat absurd? Is it that the manuals contain no stereotypes for trucks and steamboats? Or is it rather because both the style and technique of *guohua* seem to belong to a timeless past, to the world of art itself, rather than to the world of present-day visual experience? If this is so, it provides a further explanation of why so many younger painters are turning away from *guohua*, declaring that they find it "too abstract".

It must be partly to meet this objection that the Chinese art school curriculum now begins, for all students, with a thorough grounding in Western methods: drawing from casts and from the nude and draped figure, nature studies in pencil and pen. What happens when after this training the painter picks up the Chinese brush? Does it not dance off on its own to the great traditional tune? How much of realism survives? It is worth noting that one of the great modern *guohua* painters represented in this exhibition, Li Keran, began his career as a painter of Western-style propaganda figure paintings for the United Front during the Second World War, before he went to Beijing, and sat at the feet of Qi Baishi. For some artists the solution was to develop two quite distinct artistic personalities, an outstanding example being the venerable Liu Haisu. Trained as an impressionist in Paris, and still painting vibrant oils today, he shows the other side of his talent in his traditional Chinese paintings, as may be seen in his ink-monochrome "Huangshan" (no. 27), which become ever more expressionistic and untrammeled as he approaches his ninetieth year.

In this exhibition, the range of *guohua* techniques is fully represented in the flower paintings alone. There are two examples of *baimiao* (plain line), one by the Sichuan woman painter Zhu Peijun, elegant yet strong, (no. 65), the other an unusually restrained and sensitive study by Huang Yongyu (no. 17), who is less known for his *baimiao* paintings than for his brilliant-colored lotuses and landscapes, and perhaps best known of all for his design for the huge landscape tapestry that hangs behind the marble figure of Mao Zedong in his mausoleum on Tiananmen Square. All this is witness to that as-

tonishing technical virtuosity which is shown by so many Chinese, and indeed Japanese, artists.

Another highly skilled painter, of a much younger generation (she was born in 1946), is Zhao Xiuhuan, whose study of flowers by a mountain spring (no. 60) exemplifies the *gongbi hua*, but with a difference. Against a dark background her flowers, leaves and tendrils are painted with a positively Ruskinian accuracy of observation giving an effect both sumptuously decorative and a little mysterious. How much of this effect was influenced, one wonders, by the example of Japanese decorative art, how much by the work of Western artists such as Edmund Dulac? By contrast, Chen Peiqiu displays the free *xieyi* manner sparely in her painting of an orchid (no. 1).

Chen Peiqiu's husband Xie Zhiliu, doyen of the Shanghai artists, shows his mastery of *mogu* (boneless) painting in a beautiful flower study (no. 45) that almost suggests a translation of the early Monet into the language of the Chinese brush. After so delicate a work, the expressionistic painting of Fang Jizhong (no. 10), recalling the Ming eccentric Xu Wei, and the bold study of amaryllises by Xiao Shufang (no. 44), above which her husband Wu Zuoren has written an inscription in archaic characters, come almost as a visual shock. It is such pictures—and Cui Zifan's "Lotus Pond, Autumn Color" (no. 8), which seems to violate all the rules of composition and to hold together by its sheer vitality—that demonstrate that the great tradition in flower painting is still very much alive.

Yet flower painting by its very nature cannot break the mold. Fidelity to the forms of the plants themselves must determine the range of visual, spatial, emotional experience that can be conveyed. This is even truer of bamboo painting, which may explain why there is so little high-quality bamboo painting in China today, and none in this exhibition.

Landscape painting, in which the artist is not bound by the faithful rendering of a constant form—one can expressively distort a rock or a mountain, but not an orchid—presents the artist with an infinitely greater range, and far more problems and challenges. Not only are there new possibilities in the handling of space, perspective, form, color, light and

shade, and cast shadows, but the traditional limits to what is a suitable subject for landscape painting are gone. The result is that today's landscapists in China have discovered interest and beauty in subjects never before seen as paintable in China, only a few of which can be shown in this exhibition; for instance, the desert landscape of Gansu by Wu Zuoren (no. 43); ruins of the Turfan oasis by Wu Guanzhong (no. 39); the Yangzi Gorges by Ya Ming (no. 47), Liu Lun (no. 28), and Lu Yanshao (no. 29); the snows and pine forests of the northeast by Zhang Bu (no. 56). A larger exhibition would certainly have included landscapes of the tropical southwest, and more works by painters who have at last discovered and painted the beautiful towns and villages of the Jiangnan region, such as Lin Fengmian and Xu Xi, besides those by Chen Peiqiu (no. 3) and Li Wenhan (no. 26).

Only rarely in this exhibition has the artist taken his inspiration from the old masters, and when he has it does not obtrude. Lu Yanshao is clearly an admirer of Shitao, yet in his long Yangzi River handscroll Shitao-like techniques are subordinated to restless movement, and a visual interest in the dramatic scenery that holds the eye throughout the scroll. At first glance his handling of space looks slightly "Westernized", but Lu Yanshao's art owes little or nothing to foreign influences. Poet, calligrapher, seal-carver, he is steeped in tradition—so steeped indeed that, like Qian Songyan, he sees it as the obligation of the *guohua* painter not to abandon the vocabulary of conventional brushstrokes in favor of painting directly from nature, but constantly to revise and enrich it in order to embrace new kinds of subject matter, new ways of painting water, clouds, the texture of rocks. For many years after Liberation in 1949 painters were obliged to depict the "greening" of China: the vast newly-planted forests than which nothing, to the landscapist, could be more monotonous and uninteresting. Lu Yanshao's restless working of the surface of the picture, which sometimes recalls Kuncan as well as Shitao, was one solution to that problem. His paintings are never less than visually alive. In the handscroll in this exhibition, however, the seventy-four-year-old artist labors under no such constraints, and the painting expresses that joyous energy and freedom

that can be seen in a number of the old masters who were fortunate to survive beyond 1976.

Elsewhere in the exhibition, the weight of the past is carried even more lightly. Li Wenhan (no. 26) uses the manner of Dong Yuan and Mi Fu to evoke the calm luminous atmosphere and tree-clad hills of the south in so natural a way that we think of the Jiangnan region before we think of the sources of the style. If Wu Guanzhong's spare drawing of trees (no. 40) reminds us of the austere seventeenth-century master Hongren, that is because we are taught to look for it: the resemblance is probably quite accidental.

Clearly, the lifting of the weight of the past gives the modern *guohua* painter a far greater freedom. It is reflected in the range of styles in this exhibition, from the elegant eclecticism of the prolific, popular Shanghai master Cheng Shifa (nos. 4, 5, 6, 7) and the vigorous and more realistic handling of the medium in works by Fang Jizhong (nos. 10, 11) and Ya Ming (no. 47), through the subtle poetry of the Hangzhou painter Zeng Mi (no. 54) to the almost frenetic energy of the young Sichuan artist Li Huasheng (nos. 19, 20). So wide indeed is the range of techniques practiced today and labeled *guohua* that one has the impression that the term includes almost anything except oils and Western drawing methods. *Guohua* is, or it seems soon will be, whatever a Chinese painter does. When Wu Guanzhong was asked whether by painting in a foreign way he became less Chinese, he replied, "When I take up the brush to paint, I am a Chinese painter." Thus is solved, at last, the problem of the artist's identity, which was once, in the 1920s and 30s, so crucial an issue. One result of this new attitude is that Chinese artists working abroad such as Zhao Wuqi (Zao Wouki) and Zhu Dequn, both abstract-expressionist painters living in Paris, are no longer beyond the pale. They too are Chinese painters, invited to paint and exhibit in China.

Now that the artist's identity as expressed in style and technique is no longer an issue, the artist is perfectly free to employ new and revolutionary techniques: crumpling up the paper before painting, using body color sometimes mixed with clay or salt (Zhao Xiuhuan), using a broad brush like an oil painter or a ball of cotton, drawing with dry black ink as though it were charcoal, as in Yang Gang's study of "Mongolian Wrestlers" (no. 52). Now the "creative accident", such as we find in the apparently haphazard mingling of ink and mineral colors, plays its part. Some of these new techniques are influenced by Western and Japanese abstract-expressionism, some by the earlier examples of Chinese artists in Hong Kong and Taiwan. Works by the latter are well known in China through exhibitions and journals such as *Meishu* (*Art*), published in Beijing, and the glossy Beijing-inspired *Meishujia* (*Artist*) published in Hong Kong, which acts as an influential carrier of two-way traffic. It would be wrong, however, to think that all the apparently new and experimental techniques seen in this exhibition are very recent developments.

Zhu Qizhan, represented here by a strongly colored landscape that suggests the archaic *jinbi* (gold-blue/green) style, began to study oil painting in Shanghai as long ago as 1912. As an art student in Japan in the 1920s he became a pupil of Fujishima Takeji in Tokyo, where he also discovered Van Gogh and Matisse. It was not until he returned to China that he seriously began to paint in the Chinese medium, helped and stimulated by his friends Qi Baishi, Huang Binhong and Pan Tianshou. In Japan he could hardly have failed to see the work of Sueji Umehara, who created a new style of landscape painting in oils, while much later he may also have been stimulated by the free mixing of ink, watercolor, and mineral colors with which Zhang Daqian began to experiment in the 60s. In Zhu Qizhan such multiple influences are transformed into a very personal style by the sheer strength of the artist's personality. His recent work, and that of other modern Chinese masters, suggests that the time is past when we need any longer be surprised at the complex interplay of Oriental and Western elements in contemporary East Asian art.

Two more paintings in the exhibition may be taken as a token of the extent to which *guohua* has been stretched: Wu Guanzhong's "Ruins of Gaochang [Turfan]" (no. 39) and "Towering Mountain" by the woman painter Yang Yanping (no. 53), who has never been abroad but her work—whether figure studies in oils and Chinese ink, or landscapes in

a variety of media—shows a sensitivity and freshness of vision that put her in the front rank of "middle generation" painters. The influence of Raoul Dufy, which shows clearly in Wu Guanzhong's more facile earlier work is, in the Turfan painting, totally subordinated to a direct rendering of a type of landscape such as Dufy and Wu Guanzhong's forebears never saw. As for Yang Yanping, the inspiration seems to be a new feeling for form, an inner vision, that owes little to influences either from the past or from abroad.

During the last thirty years figure painting in China for obvious ideological reasons regained the dominating position it held before the Song dynasty. The human figure has once more become the vehicle to convey ethical messages that no landscape could express. The selectors of this exhibition have mercifully been able to steer clear of the crudely propagandist work which till recently had been so prominent. Nie Ou's large figure painting entitled "Dew" (no. 31), if it does idealize the innocence of workers' life, does so in an entirely natural and unaffected manner, befitting a woman painter of great sensitivity.

But that does not mean that the human figure no longer carries an ideological message, and two of the figure paintings carry such a message with power and distinction. Cheng Shifa portrays the great poet Ji Kang (no. 7) just before his execution playing the lute with majestic calm; while to suggest something of this inner turmoil of the historian Sima Qian, who accepted the humiliation of castration as the price for fulfilling his destiny as a historian, Shao Fei turns to a somewhat Westernized form of expressive realism (no. 34). This noble picture is also a good illustration of the desire of many modern Chinese artists to break free from the too refined, and too confining, elegance of traditional figure painting.

Thus even this small exhibition gives a true impression of how the great tradition has in recent years been enlivened and enriched. Yet the younger generation in China today do not find it enough. They feel that in order to paint the real world they must break entirely free from tradition. Their god is not Dong Yuan or Shen Zhou, not even the modern pioneer Xu Beihong. For the moment at least, it is

Andrew Wyeth, for the American master shows them how to approach nature direct, their vision distorted neither by pictorial conventions nor by political ideology. The aim of these young painters is to see things as they are. For this reason, the exhibition includes several sketches done from life on the spot by Yang Gang (nos. 49, 50, 51) and Zhang Bu (nos. 57, 58, 59) in a thoroughly Western manner. A number of other modern *guohua* painters not represented here also make their preliminary studies *sur le motif* in pencil or felt pen, and turn them into "Chinese paintings" when they get home. Nevertheless, more and more of the younger generation are going over almost entirely to Western styles in order to resist the inevitable tendency in the Chinese brush technique to conventionalize. In an illuminating discussion with faculty of the Central Art Academy in Beijing at which I was privileged to be present in June 1983, a teacher remarked that the young artists' rejection of *guohua*, like their indifference to the Peking Opera, was simply because they were young; they would return to it with maturity. That certainly seems possible: for the depth, subtlety and discipline, the poetic and philosophical undertones, of traditional Chinese painting preserve something infinitely precious and irreplaceable in Chinese culture.

But this does not mean that in rediscovering their traditional art the artists will reject what the modern world and the West have to offer. They cannot live without Western art either. So the truly comprehensive and representative exhibition of twentieth-century Chinese art, when the time comes to put it together, will devote as much space to the modern, Westernized and experimental trends as to art in the more traditional style. In the meantime, this exhibition represents a first step, by showing in small compass how much can be achieved and expressed by the Chinese painter today who still responds with feeling and imagination to the touch of the Chinese brush.

Excerpts from Chinese Essays on Art

Translated by Lucy Lim

Li Keran on Tradition:

Chinese landscape painting has had a long historical tradition. It is worthwhile for us to study and explore this rich artistic legacy seriously, in order to continue and further develop it.

I did not receive much education. Now that my hair has turned white, I feel that I am still a young student. I have two seals, one of which reads, "At the age of seventy, I have just learned that I am without knowledge", and the other "The white-haired student". These are not modest phrases. They merely mean that there is no end to learning. One continues to learn until the hair becomes white, and yet one is still a young student. This is common to all learning processes. But, because we all have different objectives, we take different routes in the pursuit of knowledge.

In mastering the tradition of Chinese painting, it is important to learn directly—to be taught directly. Not that one should neglect indirect knowledge, such as reading or looking at original works, or listening to those who discuss the works of artists and the creative experience. It is of course inferior to direct learning. Where works of art are concerned, rarely can words sufficiently communicate their meanings. If one had the opportunity to meet great masters, to see their paintings and ask for their advice, the personal experience would be more valuable than reading tens of thousands of words about them. I was able to learn directly from my two teachers Qi Baishi and Huang Binhong, and what I have learned I will not forget my whole life.

At the age of thirteen, I began to learn about Chinese painting, and I came to learn about the landscape art of the "Four Wangs". Later, for two years, I studied Western painting with a French teacher, and then I returned to the study of Chinese painting. After the Sino-Japanese War, I received two offers of appointments: one in Beijing, and the other in Hangzhou. Beijing is an ancient city, where the Palace Museum art collections are located. The two masters Qi Baishi and Huang Binhong also lived there. I was then forty years old. I thought: if a forty-year-old person did not take the opportunity to learn directly from his superiors, it would be a great mistake. So I decided to accept the appointment at Beijing.

I studied with Qi Baishi for ten years, during which time I chiefly learned from his creative attitude and his great ability in handling ink and brush. He had a very serious regard for the creative art, and his use of the brush was vigorous and overpowering. What he possessed was something men of our generation could never attain. To me, Qi Baishi is like a towering mountain of art.

From *Li Keran Hua Lun* (*Discussions on Painting by Li Keran*), edited by Wang Zhuo.

Cheng Shifa on Bird-and-Flower Painting:

Chinese bird-and-flower painting became an independent category of painting as a consequence of figure painting. When I first began to paint birds and flowers, they were used to supplement and fill in my figure compositions.

Life in our time is rich and colorful, arousing strong emotional responses in us. Whether we paint figures, landscapes, or birds and flowers, we are describing our life, using art to convey our feelings. Through the means of ink and brush, life becomes elevated to the realm of art.

What are we seeking in painting birds and flowers? In the Ming dynasty, two bird-and-flower painters were criticized—one for being "marvelous but not truthful", the other for being "truthful but not marvelous". Being marvelous meant that the artist was able to express his own subjective feelings through the spiritual essence of his subject matter. Being truthful refers to the outward appearance, the objective visual forms. To capture both the "truthful" and the "marvelous"—that is my objective. It is possible to paint birds and flowers in an accurate and detailed manner such as that seen in some illustrations, but this is scientific truthfulness. The goal of artistic creation is not scientific truthfulness but artistic truthfulness. In art, the subjects—whether figures, flowers, or landscapes— are given a new life, transformed by the brush of the artist. I paint birds and flowers in the same manner that I paint figures, depicting them from different viewpoints.

We ought to absorb new influences as well as to continue and develop the fine artistic legacy we have inherited from the long history of Chinese painting. There is much for us to learn from our ancient painting and folk-art traditions.

Bird-and-flower painting has made great progress in the last hundred years, through the use of different types of paper and the invention of new techniques. The application of ink—dry or wet, heavy or light— has become more skillful and varied. The Western methods of using light and color in varying degrees of gradation and tone have given new direction to Chinese painting techniques.

From the "Preface" written in 1979 by Cheng Shifa for his portfolio of forty illustrations of bird-and-flower paintings, entitled *Studies on Birds and Flowers by Cheng Shifa*.

Guan Liang on Painting the Peking Opera:

Because of my love of the Peking opera, and because of the encouragement of friends in art, literary, and dramatic circles, I have painted a number of ink-and-brush pictures using the Peking opera as my theme. It required some experiments and thought.

Thirty years ago, I began to experiment with ink-and-brush paintings of Peking opera figures. My motive was simply this: I felt that the Peking opera characters were able to move the audience deeply because they were able to express their thoughts and emotions in such subtle manner through their consummate dramatic techniques. No motion, sound, glance, or gesture of a fine actor is wasted or superfluous, but all express fully the character and the status of the person he portrays. Such a rich and colorful art form has developed through the centuries by the Peking opera artists, who derive their materials from real life. Through long practice and continuous creative process, in addition to constant improvements based on comments and responses of the audience, Peking opera has attained its present status of perfection. But, though this art form has a very popular national appeal, there are few painters who have adopted it as a theme. This seems to me a great loss and, wishing to fill the gap, I began to paint themes from the Peking opera.

In the beginning, I encountered many difficulties. For instance, every movement in Peking opera happens rapidly. My painting had to begin with a quite complete sketch, which would reveal the essential character of the figure. To do this I had to have a thorough understanding of, and deep sensitivity toward, the figure I was to depict. If not, the artistic work would be lifeless—a failure. That is to say, every painting requires longtime observation, careful understanding, and considerable thought. I had to spend a great deal of time observing the Peking opera characters on the stage, in order to capture their spirit. My friends in the theater were very helpful, giving me useful advice. Finally, in order to understand the movement, rhythm, and music of Peking opera, I even studied the art form myself for a while. But I still did not have confidence, and dared not show my works. The late Guo Moruo saw my paintings at a friend's home and gave me great encouragement; so did Ai Qing and Qi Baishi.

From the experience of those three decades, I have learned the following: 1. Peking opera is a composite art form, comprised of music, dance, facial make-up, and costumes. The dramatic styles include elements of realism as well as stylistic allusion or suggestiveness, and other features. To capture all these features in a painting requires something beyond mere documentation. 2. Peking opera, as an exceedingly evolved art form, is full of symbolic as well as realistic meanings. One therefore cannot use any single method to represent it. Basically I have adopted the traditional Chinese painting style, but I have also used other methods to portray the figures. 3. Bodily movements, facial expressions, and varying tones of voice all function in the portrayal of Peking opera characters. Each movement has its special meaning, and it is very important to capture the slight nuances in these movements, the emotions and expressions. 4. The opera is an active art form. The performance moves the audience over a period of time. To fully express the drama in a single picture, the artist must select the most moving, the most outstanding, and the most typical scene. 5. After observation and analysis, the artist must simplify, and use a style embodying some folk elements, to portray these figures from the Peking opera.

As far as I am concerned, my paintings of the Peking opera are still experimental efforts, and I need to further improve my work.

From "Ink-and-Brush Painting of Peking Opera" by Guan Liang, written on September 10, 1956, in Shanghai, and published in *Meishu* (*Art*), December 1956 and again in *Meishujikan* (*Art Journal*), 1973, Vol. 2.

A Summary Discussion on the Use of Ink and Brush in Chinese Landscape Painting by Lu Yanshao:

Traditional Chinese painting is done with a soft but supple brush. The brush absorbs the ink, which is produced by grinding the inkstone with water on an ink slab, and applies it to the absorbent rice paper. Because of the technique, the effects created are unique, different from painting with other media.

In landscape painting more than in bird-and-flower painting, the effects created by the brush and ink are highly varied, and the aesthetic ideals that it attempts to achieve are also more demanding. Since ancient times, discussions on the methods of landscape painting and its principles have emphasized the use of ink and brush.

The movements of the brush on the paper are recorded by the traces of ink. Ink, therefore, is used to serve the brush, and is subordinate to it. For instance, in his "Six Elements of Painting", the fifth-century critic Xie He spoke of the "bone method" of brushwork, used to produce masterly and vigorous strokes. [The "Six Elements" are part of a critical treatise entitled *Guhua pinlu* (*On the Classification of Painters*).] This shows the important position that the brush occupies in Chinese landscape painting techniques.

The use of the brush in landscape painting is mainly expressed in the *dian* (dots) and the line. The artist spreads out the paper before him, loosens his garments, and empties his mind, so as to focus his energy on the tip of the brush. Dots and lines do not merely float on the picture surface, but the brush penetrates the paper and exerts its strength upon it. There are different methods of using the brush— bluntly or meticulously, heavily or lightly. There are also various ways of holding the brush.

When describing outward appearance and visual forms, Chinese painting seeks to strike a balance between truthfulness and non-truthfulness. Non-truthfulness means that the ink and brush—when well applied—assume their independent character. Besides being descriptive, the forms may be be appreciated for their abstract, formalistic value. This

is the same as in calligraphy, which explains why painters must master the art of calligraphy in order to paint well.

Because of the various methods of using the brush, there is a sequence of developments from simple to complex in the technique of brushwork. The use of ink is also varied—splashed-ink, broken-ink, layered-ink, etc. It is sometimes used sparingly, sometimes freely and abundantly.

All methods, however, are dead and meaningless in themselves. They become alive only when they are applied and transformed in the creative process. Then the non-method becomes a method. This principle is also true for the use of ink and brush, as well as for the application of colors and other methods in painting.

From Lu Yanshao's article of the same title published in the journal *Zhongguo hua* (*Chinese Painting*), 1982, Vol. 1.

On the Heavily Colored *Gongbi Hua* ("Meticulous Method of Painting"):

The heavily colored *gongbi hua* is a special method of Chinese painting, which differs from the *xieyi* ("idea-writing") and the *baimiao* ("ink-outline") styles as well as paintings done in pale colors. It is characterized by fine and meticulous craftsmanship, brilliant colors, and decorative quality, being a highly descriptive type of art.

Gongbi hua has a long history in Chinese art. Archaeological discoveries have uncovered a silk banner painting from the Warring States period of two thousand years ago, depicting a figure and a dragon which shows the stylistic tendencies of *gongbi hua*. The lines in this painting are fluid and continuous; there is indication of the use of colors, including gold and white powder. The earliest *gongbi hua* that is known to us today is a silk banner painting dating to the Western Han dynasty. This work, [found in a tomb draped over a coffin], is of considerably high artistic quality.

Examples of *gongbi hua* may be seen in the painted wall murals and scrolls of the later dynasties throughout Chinese history. According to the noted writer Lu Xun of the twentieth century, *gongbi hua* reached its height during the Tang dynasty and may be seen in the Buddhist art which flourished during that period.

Three years after the demise of the "Gang of Four", Chinese art has a new flowering—a hundred flowers blossoming. Artists practicing *gongbi hua* have continued to produce new works. There are nevertheless some critics who consider *gongbi hua* to be of lesser artistic value. But in fact the quality of artistic works executed in the various methods depends on the ability, sensitivity, and imagination of the artists who create them.

There are many excellent examples of *gongbi hua* in ancient and contemporary Chinese painting. Outstanding among them is the "Lo River Goddess" handscroll by Gu Kaizhi [the famous figure painter of the fourth century], known for his descriptive realism as well as his ability to portray the spiritual character of the figures he painted. Through finely drawn, descriptive lines that were like "silk thread", he was able to capture the inner spirit through the depiction of outward form and appearance.

Among modern painters, some have devoted their entire careers to the mastery of *gongbi hua*, such as the late Yu Feian, Liu Lingcang, and others. Their works have achieved high artistic status.

Gongbi hua relies both on tradition and on experience. The method was also employed in Chinese folk art, as may be seen in the *nien-hua* or New Year's Pictures and other arts-and-crafts products. Some of these reflect the style of life of the time and are extremely well done.

From "A Discussion on the Heavily Colored *Gongbi Hua*" by Wang Zeqing, published in *Zhongguo shuhua* (*Chinese Calligraphy and Painting*), Vol. 4.

My Artistic Career by Wu Guanzhong:

It was my father's dream that I should be a school-teacher. But to be a schoolteacher was equivalent to a life of porridge—of being poor. This was how we joked among ourselves. Finally I gained entry into the highly competitive college of electrical technology of the Zhejiang University. Using technology to save the country would be a noble path. At least, there would be the guarantee of a job after graduation. But was that fortunate? Or unfortunate?

By chance, I met the art specialists of Hangzhou, and I fell madly in love with art. I was at an age when my emotions were like those of a wild horse. Because of this love, and against my father's admonitions, I did not consider the future but plunged into study at the art institute of Hangzhou, to struggle and taste the bitterness of poverty and joblessness! I was not afraid—I just did not wish my parents to see their son sinking. At the time, I was most envious of those who did not have parents—who could wander freely and belong to themselves.

The Sino-Japanese war exploded, and I followed the art institute's move into the inner regions. Communication from home was cut off. I had truly become a wanderer, able to devote my entire self to art.

As the saying goes, "The water flows to the lower regions, while man climbs to the heights". I became a college art instructor, having gone beyond my father's dream.

To study abroad! That was the only future for us instructors. Many of our teachers had studied in France and spoke of their hardships, some having worked as handymen aboard ships for lack of transportation money. If only I could go abroad—to do hard work, even to live like a vagabond—it would all be for the sake of art! But not knowing the French language, how could I mix and make a bare living? So I was determined to learn French, and began to attend the French classes at the Central University. A French Catholic priest gave me lessons. In rain and snow, I never missed a class. When I still had some energy left, I went to the old bookshops in Chongqing to look for French novels and Chinese translations of them, to read side by side. At that time, during the war, we were eating very coarse rice, full of grains, sand, and tiny stones. As we ate, we had to search through the rice carefully to pick out the sand and stones. Our minds became intensely concentrated—it was just like studying French and looking up words in the dictionary, I thought!

Happiness came—the Japanese surrendered. Soon after, the Ministry of Culture announced that it had scholarships for two art students to study abroad. I seized this opportunity. Several months of agony passed, while waiting for the results of the competition. At last, I was selected—and I went to Paris. It was no longer a dream; it was real.

For the first three days in Paris, I visited all the museums and felt intoxicated. But my yellow face and my short figure and the provincial suit that I was wearing—none of these helped gain me respect in the foreign land. Even though I did not encounter many instances of blatant prejudice, who is not sensitive when it comes to self-respect? I could not speak French fluently, and did not feel at ease. I could not even use my own language to speak with anyone. It made me feel inferior. But I endured it, for the sake of learning.

Half a year, then a year, passed. I began to experience sincerity, respect, and affection from my fellow students and teachers. The language of art has no lies. One sees at once what is true, what is false, what is deep, and what is shallow in the artistic presentation. It is not like a basketball game, when the taller ones are sure to be the winners.

At the end of three years, when my scholarship ended, my teacher asked whether I wished to have it extended. I declined, for I had decided to go home to my country. He was somewhat surprised, as if he felt something remiss. He said, "You are the best student in the class. You have worked the hardest and progressed the most. Whatever I have taught, you have been able to absorb. But art is a crazy, emotional thing. I have no way to teach you— if you must return to your motherland, go and develop from the foundation that your ancestors built!"

It was natural for my teacher to find my decision unexpected, for I had intended to stay on—even to live there forever. My sudden decision to return to China was also something I had not planned. The truth was that my mother had just had an operation, and was slowly recovering her health. I had already experienced the life of an orphan—and now I longed for my mother, for her health and long life.

Whether or not to return to China posed a dilemma for all of us students abroad. It created a jolt in our minds and, openly or secretly, we began to examine our feelings toward the motherland. The environment in Paris was so conducive to studying, and it was the art center of the world. I had only been there three years, and I harbored greater ambitions that were yet to be fulfilled. Would I not feel a loss in returning now?

No, I had to return. My artistic career was in China—and there was a new China beckoning to me. So I finally decided to return to China and boarded a ship in the summer of 1950.

From *Meishujia* (*Artist*), Vol. 30

Catalogue Entries and Plates

CHEN PEIQIU (1922–), Shanghai woman artist.

"Orchid", undated.
 Signed Peiqiu, one seal.
 Chinese ink and color on paper.

38.3 × 37.5 cm. (15 × 14¾ inches)

陳佩秋（1922－），上海女畫家。
"蘭花"。
簽名佩秋。
水墨設色紙本直幅。

"Purple Fungus", undated.
 Signed Peiqiu, one seal.
 Fan painting, Chinese ink and color on paper.

25 × 53.5 cm. (9¾ × 21 inches)

"紫芝圖"（自題）。
簽名佩秋。
水墨設色紙本扇面。

CHEN PEIQIU (1922–), Shanghai woman artist.

"Mountain Village on the Bank of the Xin'an River",
dated 1976.
Signed Chen Peiqiu, one seal.
Chinese ink and color on paper.

35 × 35 cm. (13¾ × 13¾ inches)

陳佩秋（1922–），上海女畫家。
"新安江沿岸山村"（自題），作於1976年。
簽名陳佩秋。
水墨設色紙本。

Plate 3

CHENG SHIFA (1921–), Shanghai artist.

"Lichee", undated.
 Signed Cheng Shifa, three seals.
 Chinese ink and color on gold paper.

42.2 × 31.5 cm. (16⅝ × 12⅜ inches)

"Begonia", undated.
 Signed Shifa, two seals.
 Chinese ink and color on gold paper.

42.2 × 31.5 cm. (16⅝ × 12⅜ inches)

程十髮（1921－），上海畫家。
"荔子"。
簽名程十髮。
水墨設色金箋直幅。

"秋海棠"。
簽名十髮。
水墨設色金箋直幅。

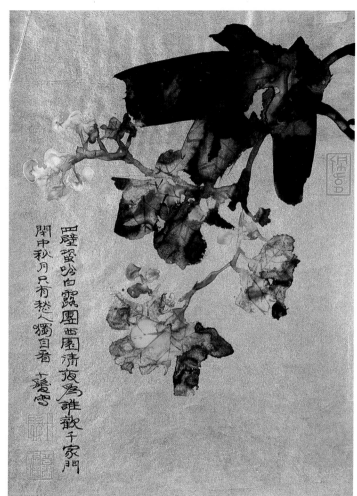

CHENG SHIFA (1921–), Shanghai artist.

"Autumn Scene", dated *xin you*, 1981.
Signed Cheng Shifa, three seals.
Hanging scroll, Chinese ink and color on paper.

111 × 74 cm. (43¾ × 29⅛ inches)

程十髮（1921－），上海畫家。
"莫釐秋色"（自題），作於辛酉年（1981）。
簽名程十髮。
水墨設色紙本立軸。

Plate 6

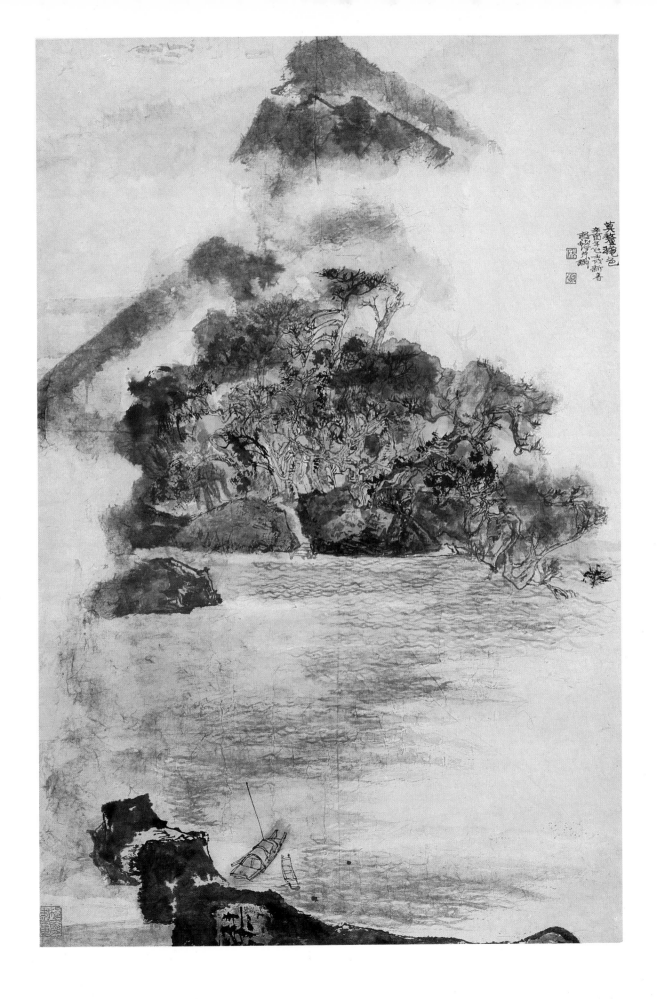

CHENG SHIFA (1921–　), Shanghai artist.

"Ji Kang", dated *geng shen*, 1980, twelfth month.
Signed Cheng Shifa, three seals.
Hanging scroll, Chinese ink and color on paper.

129.3 × 79 cm. (50⅞ × 31⅛ inches)

程十髮（1921－），上海畫家。
"稽康"，作於庚申年嘉平（1980）。
簽名程十髮。
水墨設色紙本立軸。

Plate 7

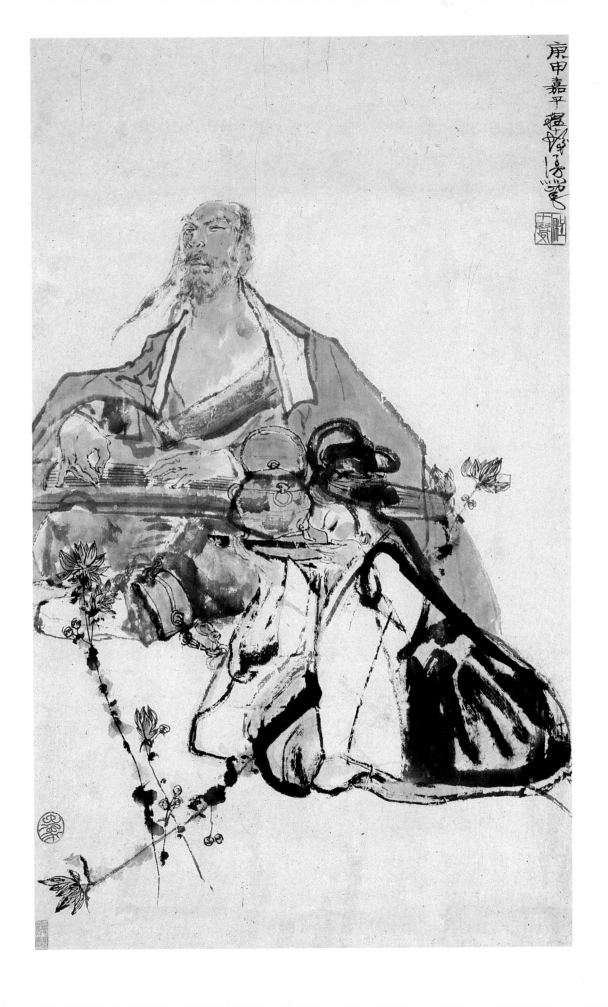

CUI ZIFAN (1915–), Beijing artist.

"Lotus Pond, Autumn Color", dated *geng shen*, 1980.
Signed Zifan, one seal.
Chinese ink and color on paper.

69.2×68.2 cm. (27¼×26⅞ inches)

崔子范（1915–），北京畫家。
"荷塘秋色"，作於庚申年（1980）。
簽名子范。
水墨設色紙本直幅。

Plate 8

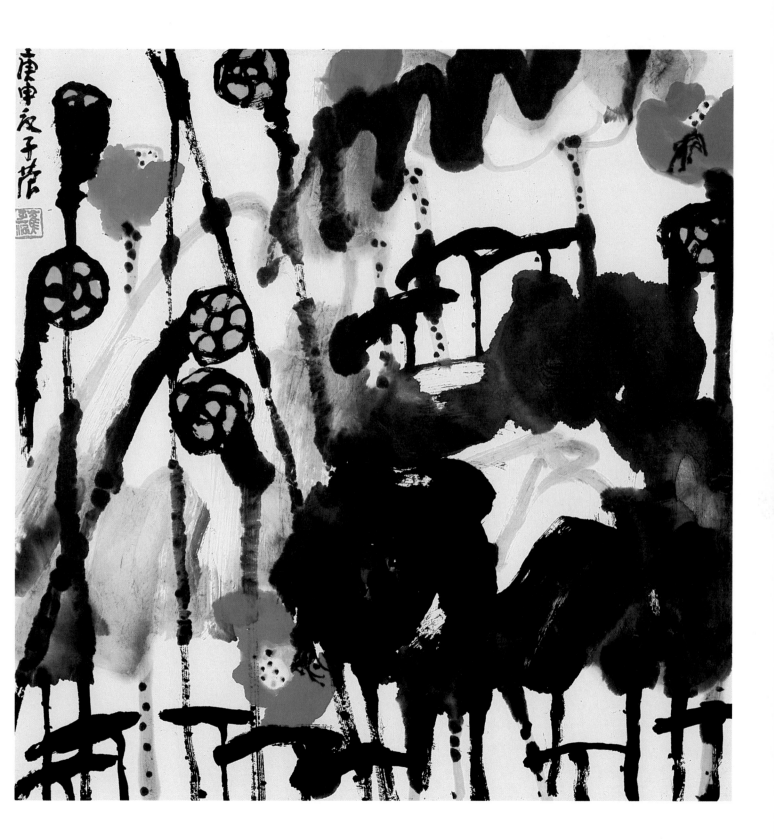

CUI ZIFAN (1915–), Beijing artist.

"Pea-pods", dated *xin you*, 1981, autumn.
Signed Zifan, one seal.
Chinese ink and color on paper.

68 × 45 cm. (26¾ × 17¾ inches)

崔子范（1915–），北京畫家。
"豆角"，作於辛酉年秋（1981）。
簽名子范。
水墨設色紙本直幅。

Plate 9

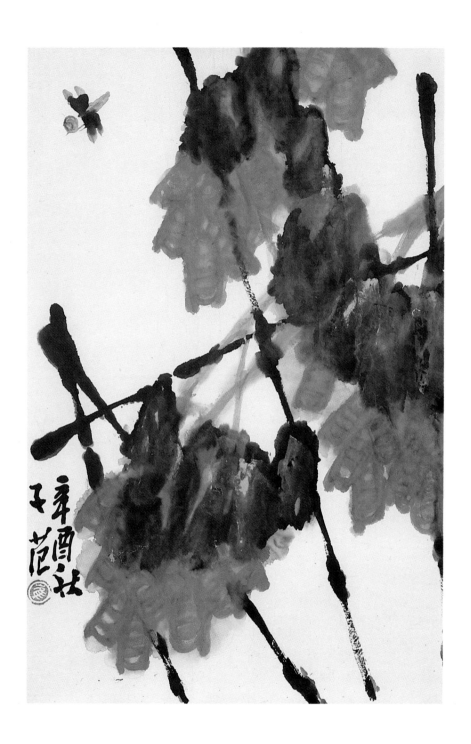

FANG JIZHONG (1923–), Xi'an (Shaanxi) artist.

"Ink Lotuses", dated March 31, 1981.
Signed Jizhong, three seals.
Chinese ink on paper.

17 × 68 cm. (6¾ × 26¾ inches)

方濟衆（1923–），西安（陝西）畫家。
"墨荷"，作於1981年3月31日。
簽名濟衆。
水墨紙本橫幅。

"Mountain Dwelling", dated April, 1981, painted at the
Yan'an Restaurant in Shanghai.
Unsigned, two seals of the artist.
Chinese ink and color on paper.

17 × 68 cm. (6¾ × 26¾ inches)

"山居圖"，1981年4月作於上海延安飯店。
沒簽名，有圖章"濟衆"。
水墨設色紙本橫幅。

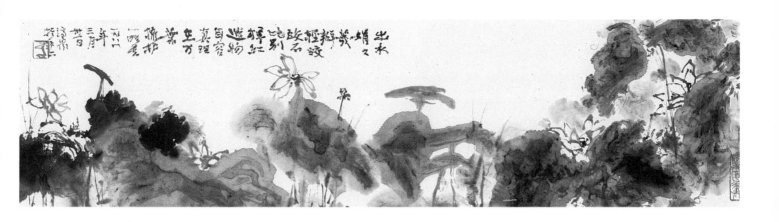

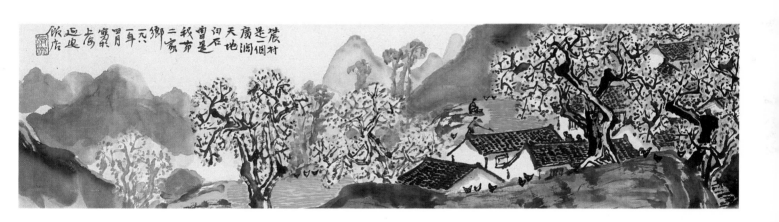

FANG ZENGXIAN (1931–), Hangzhou (Zhejiang) artist.

"Zhong Kui", dated *gui hai*, 1983, first month.
Signed Zengxian, three seals.
Fan painting, Chinese ink and color on paper.

26 × 55 cm. (10¼ × 21½ inches)

方增先（1931－），杭州（浙江）畫家。
"鍾馗"，作於癸亥年元月（1983）。
簽名增先。
水墨設色紙本扇面。

Plate 12

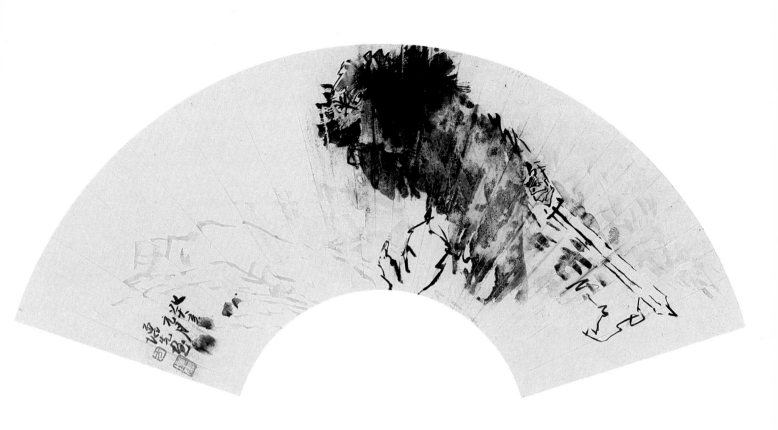

GUAN LIANG (1900–), Shanghai artist.

"Zhong Kui Marrying Off His Sister", dated *gui hai*, 1983,
fourth month, painted in Shanghai.
Signed Guan Liang, two seals.
Chinese ink and color on paper.

46.2 × 67.2 cm. (18¼ × 26½ inches)

關良（1900－），上海畫家。
"鍾馗嫁妹"（自題），癸亥年四月（1983）
作於上海。
簽名關良。
水墨設色紙本橫幅。

Plate 13

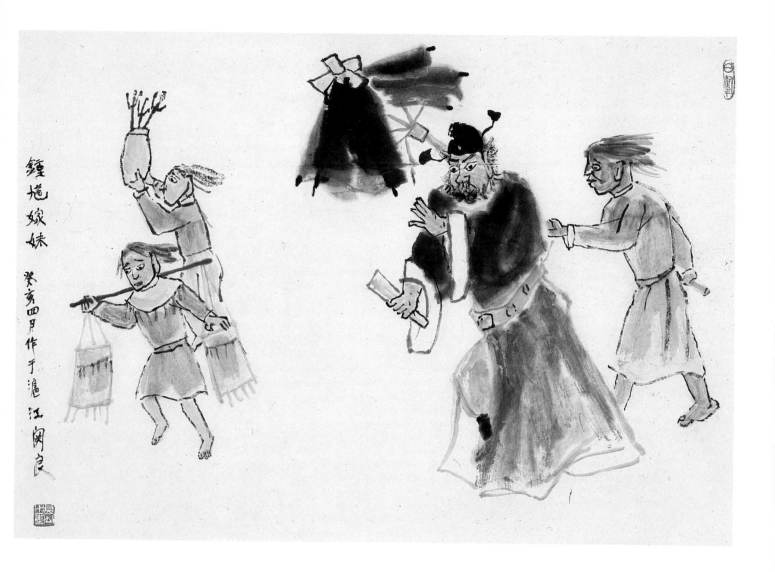

GUAN LIANG (1900–), Shanghai artist.

"Scene from the Peking Opera", dated *ren xu*, 1982, autumn.
Signed Guan Liang, one seal.
Chinese ink and color on paper.

67.3×45 cm. (26½×17¾ inches)

關良（1900-　），上海畫家。
"武劇圖"（自題），作於壬戌年秋（1982）。
簽名關良。
水墨設色紙本直幅。

Plate 14

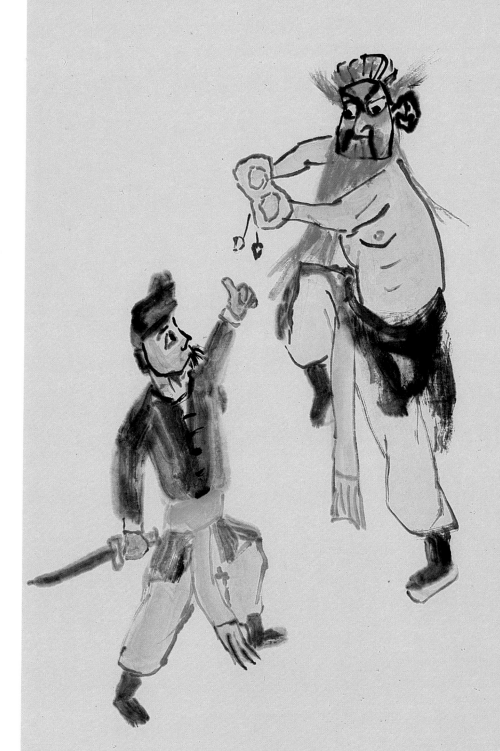

壬戌秋日寫武劇圖
書昇關良客滬江

GUAN LIANG (1900–), Shanghai artist.

"Ten Heroic Figures from the *Water Margin* [historical novel]", undated.
Frontispiece inscribed by the artist.
Each leaf signed and stamped with the seal of the artist.
Album with 10 paintings, Chinese ink and color on paper.

22.7×18 cm. (18×14 inches)

關良（1900–　），上海畫家。
"水滸英雄人物圖十幅"（自題）。
簽名關良。
水墨設色紙本冊頁。

Plate 15

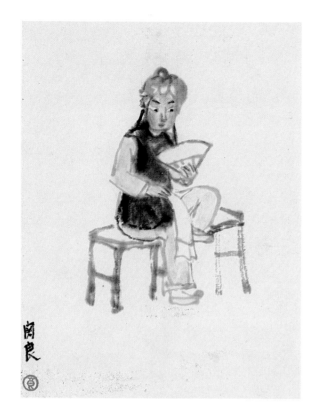

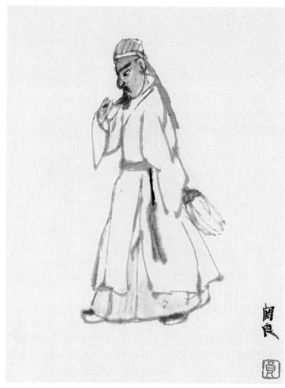

Plate 15

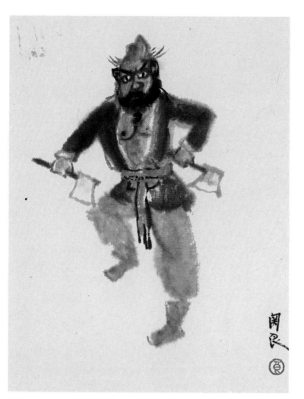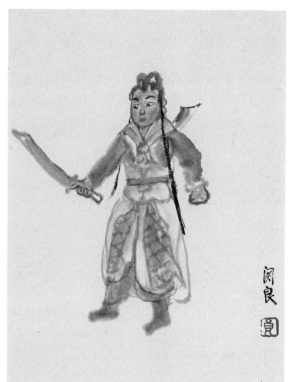

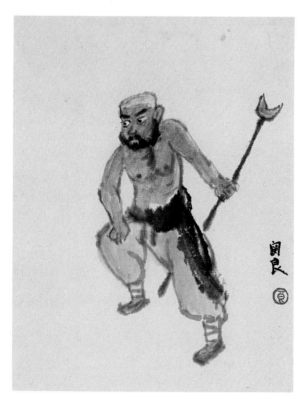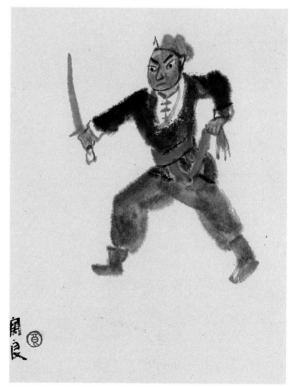

GUAN SHANYUE (1912–), Guangzhou (Canton) artist.

"In the Shade of the Banyan Tree", dated 1962.
Signed Guan Shanyue, two seals.
Hanging scroll, Chinese ink and color on paper.

95 × 56.8 cm. (37⅜ × 22⅜ inches)

關山月（1912－），廣州畫家。
"榕萌曲"（自題），作於1962年。
簽名關山月。
水墨設色紙本立軸。

Plate 16

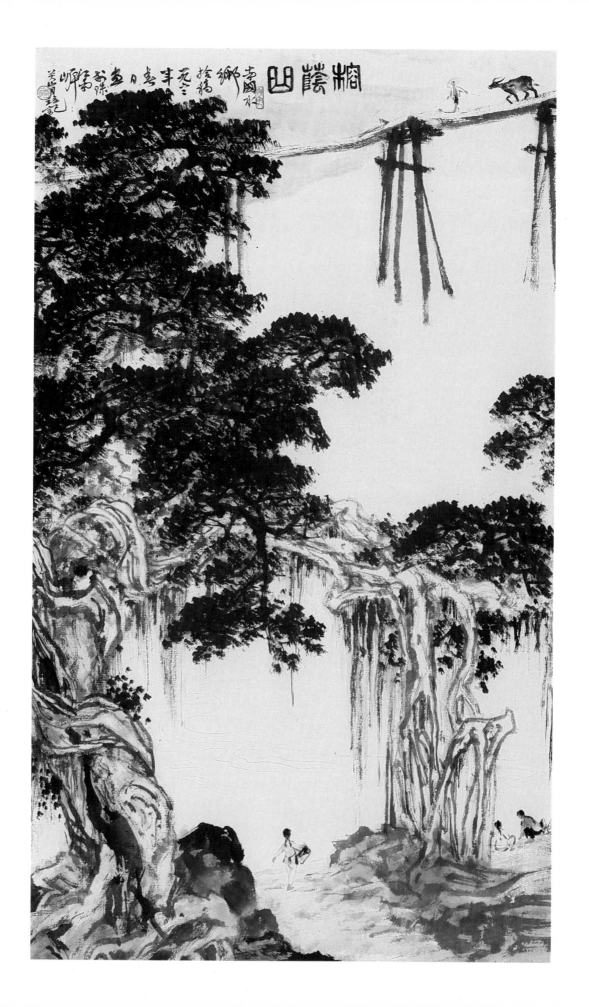

HUANG YONGYU (1924–), Beijing artist.

"Baimiao Lotuses", dated *xu you,* 1981.
Signed Huang Yongyu, four seals.
Hanging scroll, Chinese ink on paper.

130.5 × 63.5 cm. (51¼ × 25 inches)

黃永玉（1924－），北京畫家。
"白描荷花"，作於辛酉年（1981）。
簽名黃永玉。
白描紙本立軸。

Plate 17

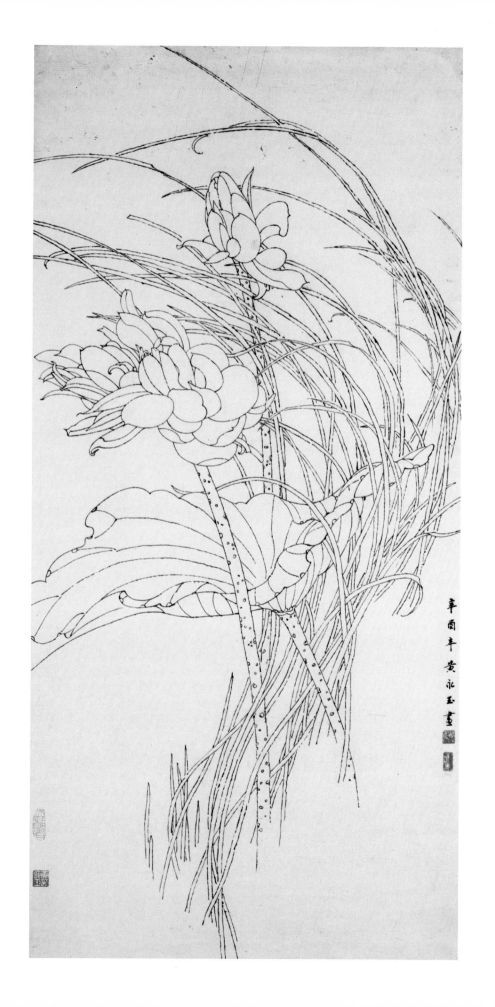

LI GENG (1950–), Beijing artist.

"Gazing at the Fish from the Pavilion", undated.
Signed Li Geng, five seals.
Chinese ink and color on paper.

55 × 27.3 cm. (21⅝ × 18⅝ inches)

李庚（1950－），北京畫家。
"捲簾倚欄看魚圖"（自題）。
簽名李庚。
水墨設色紙本直幅。

Plate 18

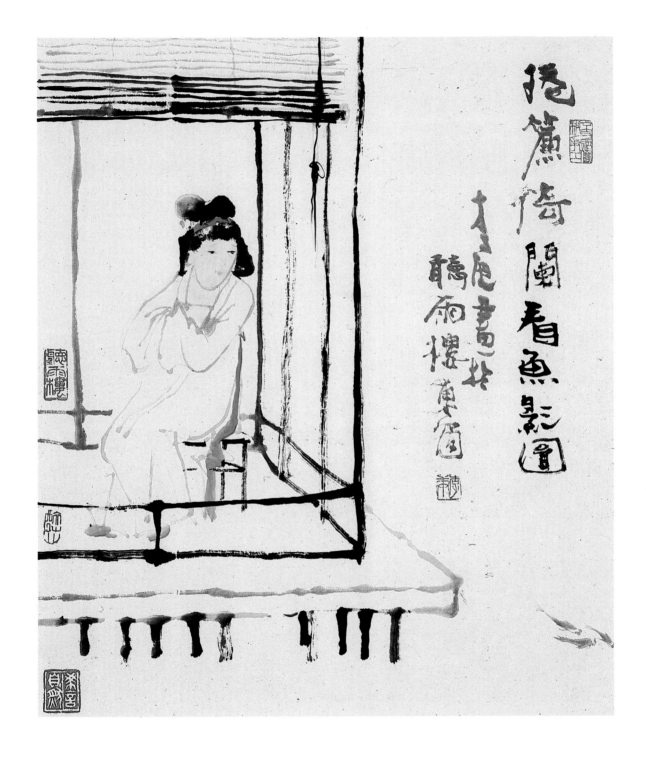

LI HUASHENG (1944–), Chongqing (Sichuan) artist.

"Village Scene", undated.
Signed Huasheng, two seals.
Hanging scroll, Chinese ink and color on paper.

136 × 68 cm. (53½ × 26¾ inches)

李華生（1944－），重慶（四川）畫家。
"村景"。
簽名華生。
水墨設色紙本立軸。

Plate 19

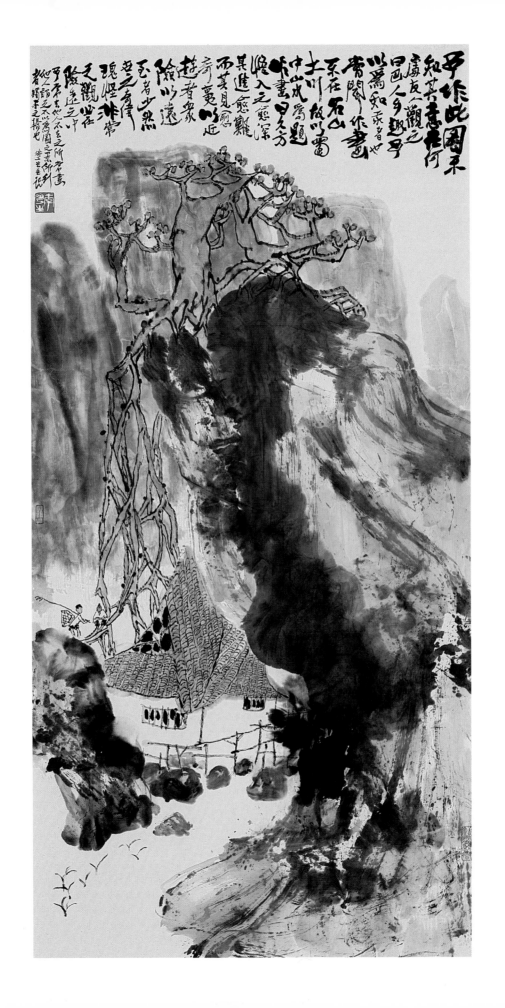

LI HUASHENG (1944–), Chongqing (Sichuan) artist.

"Farmhouse", undated.
 Unsigned, one seal of the artist.
 Hanging scroll, Chinese ink and color on paper.

 136 × 68.5 cm. (53½ × 27 inches)

李華生（1944-），重慶（四川）畫家。
"莫笑農家臘酒渾"（自題）。
沒簽名，有圖章"華生"。
水墨設色紙本立軸。

Plate 20

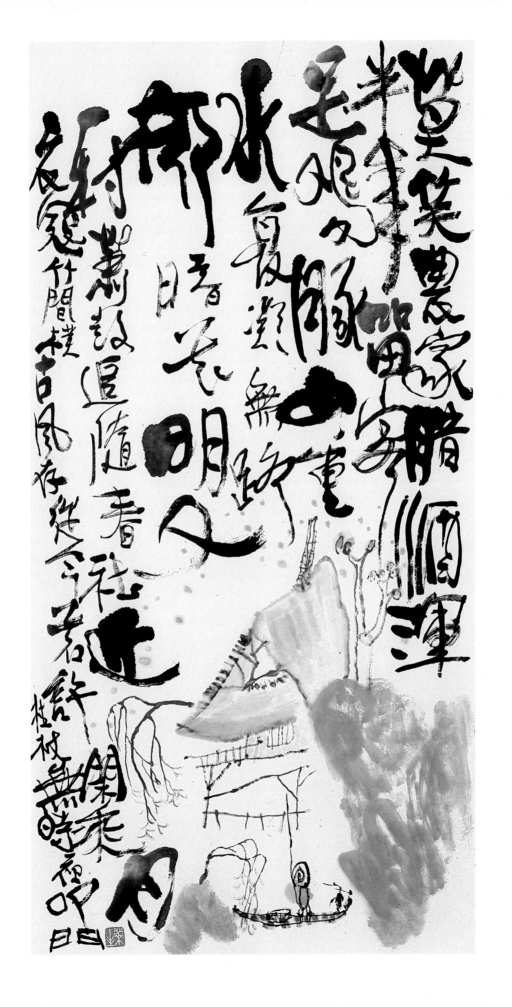

LI KERAN (1907–), Beijing artist.

"Laughing Monk", dated *gui hai,* 1983.
Signed Keran, four seals.
Chinese ink and color on paper.

69 × 46 cm. (27¾ × 18¾ inches)

李可染（1907－），北京畫家。
"笑和尚圖"（自題），作於癸亥年（1983）。
簽名可染。
水墨設色紙本直幅。

Plate 21

笑和尚圖

大肚能容 容天下難容之事
開顏便笑 笑世間可笑之人

LI KERAN (1907–), Beijing artist.

"Playfulness in the Autumn", dated *ren xu*, 1982.
Signed Keran, two seals.
Chinese ink and color on paper.

68.5 × 45.7 cm. (27 × 18 inches)

李可染（1907－），北京畫家。
"秋趣圖"（自題），作於壬戌年（1982）。
簽名可染。
水墨設色紙本直幅。

Plate 22

LI KERAN (1907–), Beijing artist.

"Rain at the Li River [Guilin]", dated 1961, summer.
Signed Keran, three seals.
Chinese ink and color on paper.

69.5 × 46 cm. (27⅜ × 28⅛ inches)

李可染（1907），北京畫家。
"灕江雨"，作於1961年夏。
簽名可染。
水墨設色直幅。

Plate 23

LI KUCHAN (1898–1983), Beijing artist.

"Two Birds Under the Pine Tree", dated *jia chen*, 1964, autumn.
Signed Kuchan, one seal.
Hanging scroll, Chinese ink and color on paper.

65.5 × 59.2 cm. (25¾ × 23¼ inches)

李苦禪（1898－1983），北京畫家。
"雙禽松月圖"，作於甲辰年秋（1964）。
簽名古禪。
水墨設色紙本立軸。

Plate 24

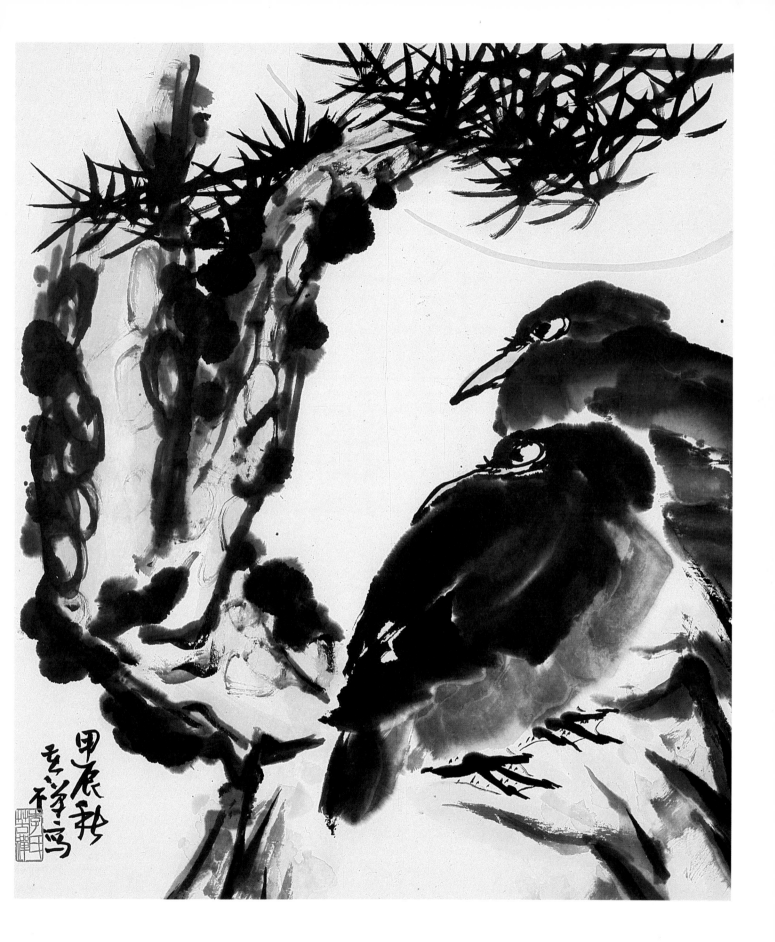

LI KUCHAN (1898–1983), Beijing artist.

"Vegetables", undated.
Signed Li Gong, one seal.
Chinese ink and color on paper.

35 × 45.3 cm. (13¾ × 17⅞ inches)

李苦禪（1898－1983），北京畫家。
"蔬肥"（自題）。
簽名勵公。
水墨設色紙本橫幅。

Plate 25

蒜肥

翁文彪

LI WENHAN (1937–), Beijing artist.

"Impression of the Xin'an River", dated *ren xu*, 1982, third month.
Signed Wenhan, two seals.
Chinese ink and color on paper.

82.5×76.4 cm. (32⅜×30 inches)

李問漢（1937－），北京畫家。
"新安江印象"（自題），作於壬戌年三月
（1982）。
簽名問漢。
水墨設色紙本直幅。

Plate 26

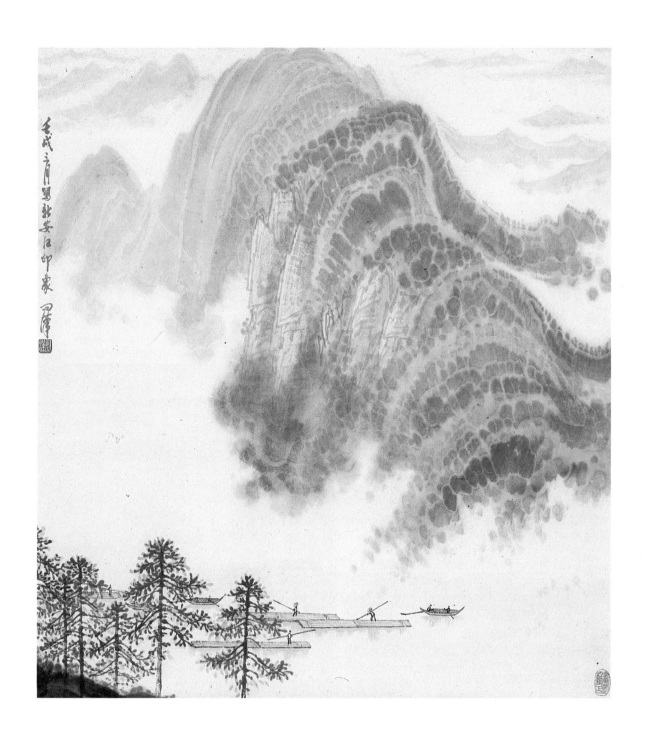

LIU HAISU (1896–), Shanghai artist.

"Peaks and Clouds of Huangshan", dated August 19, 1982.
Signed Liu Haisu, two seals.
Hanging scroll, Chinese ink on paper.

67.3×137.2 cm. (26⅝×54 inches)

劉海粟（1896－），上海畫家。
"天都峯雲烟"，作於1982年8月19日。
簽名劉海粟。
水墨紙本立軸。

Plate 27

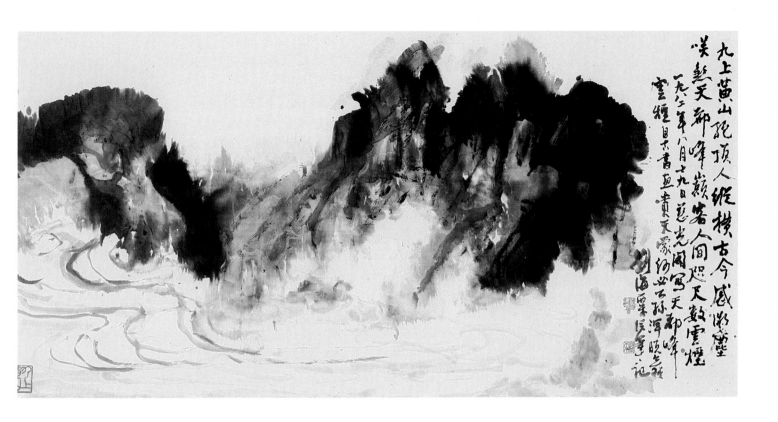

九上黃山絕頂人縱橫古今感激塞
嘆氣天都峰巔客人同照天數雲煙
雲經目不書畫貴天家物必云孫渾瞭蒼
一九八二年八月十九日慈光閣寫天都峰

劉海粟年八十七記

LIU LUN (1913–), Guangzhou (Canton) artist.

"Yangzi Gorges", dated *si wei*, 1979, spring, painted in Guangzhou.
Signed Liu Lun, two seals.
Hanging scroll, Chinese ink and color on paper.

58.5×45.8 cm. (23⅛×18 inches)

劉侖（1913-　），廣州畫家。
"三峽"（自題），己未年春（1979）
作於廣州。
簽名劉侖。
水墨設色紙本立軸。

Plate 28

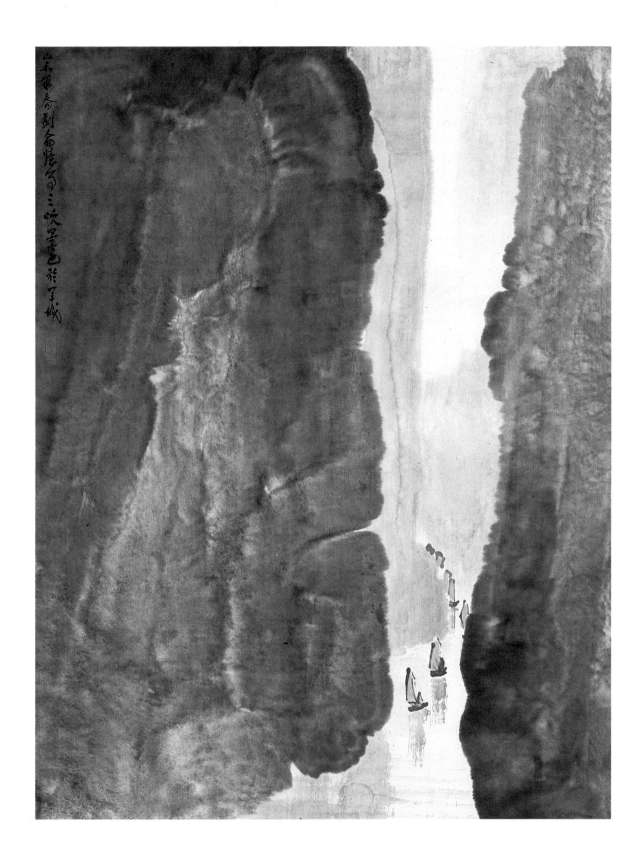

LU YANSHAO (1909–), Shanghai artist.

"Journey Down the Yangzi River", dated *xin you*, 1981, autumn.
Signed Lu Yanshao, four seals.
Handscroll, Chinese ink and color on paper.

32.5×277 cm. (12⅞×109⅛ inches)

陸儼少（1909－），上海畫家。
"峽江圖"，辛酉年秋日（1981）作於北京。
簽名陸儼少。
水墨設色紙本手卷。

Detail of the title inscribed by Sha Menghai.

卷頭83歲沙孟海題"眞宰上想"。

Detail of the colophon inscribed by the Shanghai artist Xie Zhiliu dated *ren xu* (1982) at Heping Restaurant, Shanghai.

卷尾畫家謝稚柳題壬戌冬日同在和平飯店見示，因題。

Plate 29

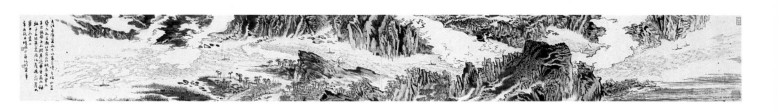

真宰上愬

LU YANSHAO (1909–), Shanghai artist.

Details of the handscroll "Journey Down the Yangzi River".

陸儼少（1909–），上海畫家。
"峽江圖"局部。

Detail of the inscription written by Lu Yanshao at the end of the painting.

Plate 29

LU YANSHAO (1909–), Shanghai artist.

"The Wind in the Jiangnan is Warm", dated *ren xu*, 1982,
third month.
Signed Lu Yanshao, three seals.
Fan painting, Chinese ink and color on paper.

24 × 50.5 cm. (9½ × 19⅞ inches)

陸儼少（1909－），上海畫家。
"江南風暖"（自題），作於壬戌年3月
（1982）。
簽名陸儼少。
水墨設色紙本扇面。

Plate 30

NIE OU (1948–), Beijing woman artist.

"Dew", dated 1981, summer.
Unsigned, one seal of the artist.
Hanging scroll, Chinese ink and color on paper.

164.5 × 94.8 cm. (64¾ × 37½ inches)

聶歐（1948－），北京女畫家。
"露氣"（自題），作於1981年夏。
沒簽名，有圖章"聶歐"。
水墨設色紙本立軸。

Plate 31

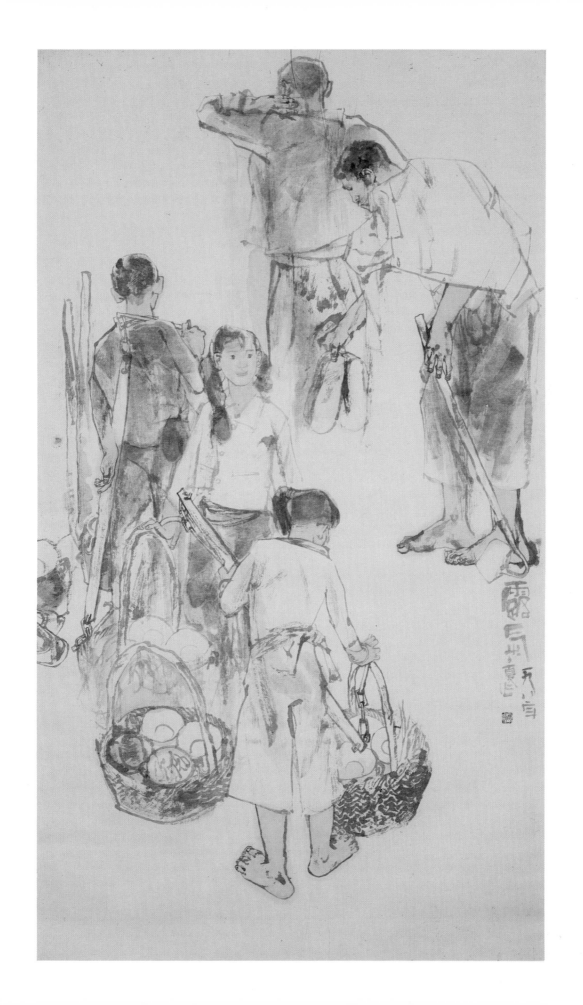

PENG PEIQUAN (1941–), Beijing artist.

"New Rain", dated *ren xu*, 1982, summer, painted at the
Beijing Painting Academy.
Signed Peiquan, one seal.
Hanging scroll, Chinese ink, color, and gold on paper.

137.5×67 cm. (55×26½ inches)

彭培泉（1941－），北京畫家。
"新雨"（自題），壬戌年夏月（1982）
作於北京畫院。
簽名培泉。
水墨設色紙本立軸。

Plate 32

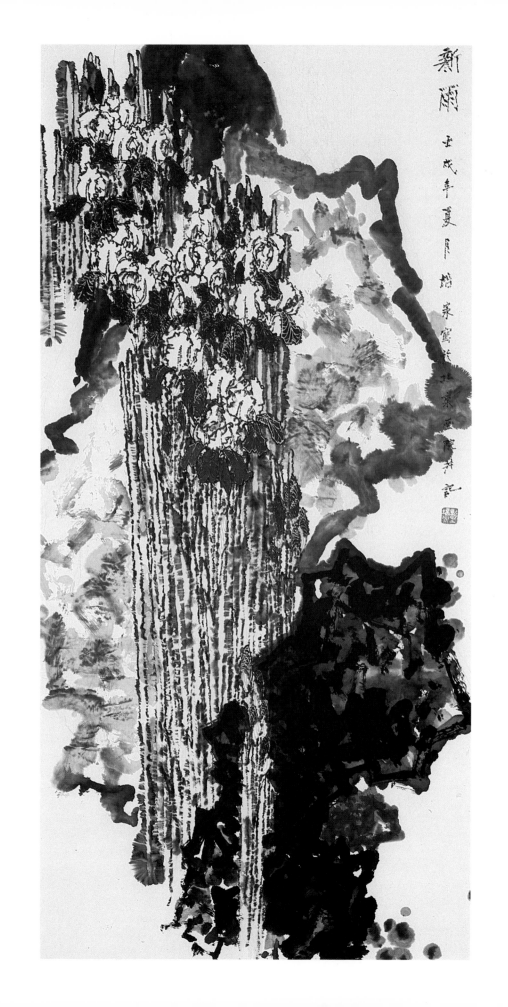

PENG PEIQUAN (1941–), Beijing artist.

"Evening Wind", dated *geng shen*, 1980, spring.
Signed Peiquan, two seals.
Chinese ink and color on paper.

154 × 66 cm. (60¾ × 26 inches)

彭培泉（1941－），北京畫家。
"晚風"（自題），作於庚申年春月（1980）。
簽名培泉。
水墨設色紙本直幅。

Plate 33

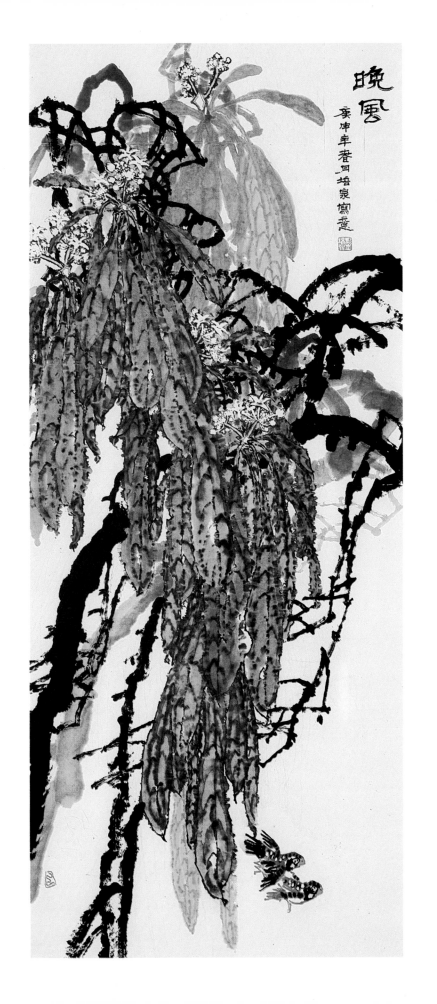

SHAO FEI (1954–), Beijing woman artist.

"Last Song of the Grand Historian [Sima Qian]", dated
xin you, 1981.
Signed Shao Fei, one seal.
Hanging scroll, Chinese ink and color on paper.

174 × 95.2 cm. (68½ × 37½ inches)

邵飛（1954－），北京女畫家。
"史家之絕唱"（自題），作於辛酉年（1981）。
簽名邵飛。
水墨設色紙本立軸。

Plate 34

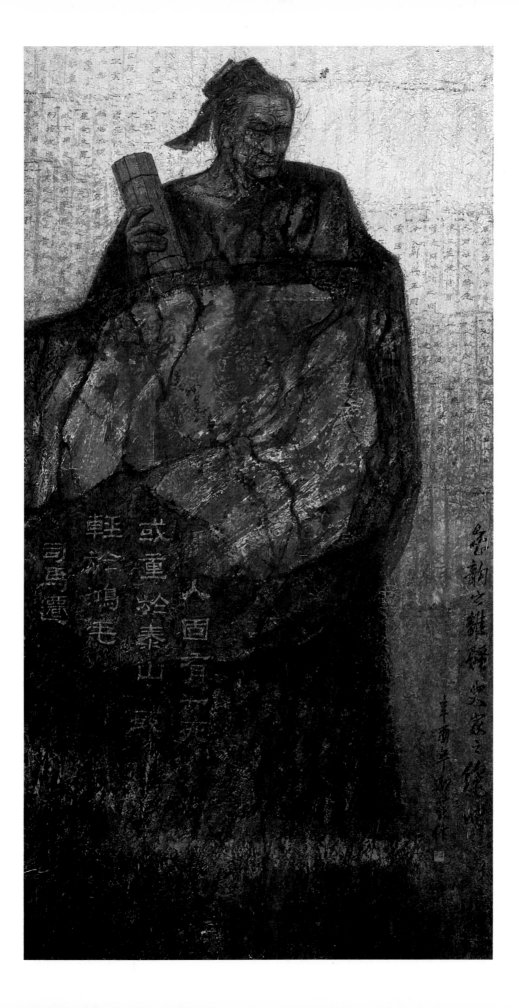

SONG WENZHI (1919–), Nanjing (Jiangsu) artist.

"Morning Rhythm", dated *xin you*, 1981,
third month.
Signed Wenzhi, three seals.
Hanging scroll, Chinese ink and color on paper.

41.7 × 69.7 cm. (16⅜ × 27½ inches)

宋文治（1919－），南京（江蘇）畫家。
"晨韻"（自題），作於辛酉年３月（1981）。
簽名文治。
水墨設色紙本立軸。

Plate 35

SONG WENZHI (1919–), Nanjing (Jiangsu) artist.

"Landscape", undated.
　Unsigned, one seal of the artist.
　Chinese ink and color on paper.

　27 × 38 cm. (10¾ × 15 inches)

宋文治（1919－），南京（江蘇）畫家。
"山水"。
沒簽名，有圖章"文治"。
水墨設色紙本橫幅。

"Landscape", dated *geng shen*, 1980, winter, painted at
Tangshan.
　Signed Wenzhi, four seals.
　Chinese ink and color on paper.

　27 × 48.5 cm. (10¾ × 19 inches)

宋文治（1919－），上海（江蘇）畫家。
"山水"，庚申年冬日（1980）作於湯山。
簽名文治。
水墨設色紙本橫幅。

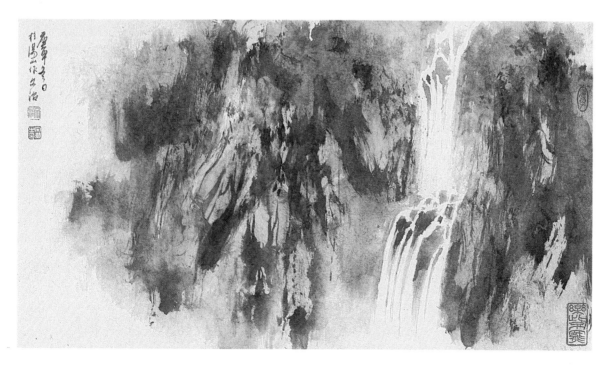

TANG YUN (1910–), Shanghai artist.

"Squirrel", undated.
Signed Tang Yun, two seals.
Chinese ink and color on paper.

34 × 34 cm. (13⅜ × 13⅜ inches)

唐雲（1910–　），上海畫家。
"松鼠"。
簽名唐雲。
水墨設色紙本。

Plate 38

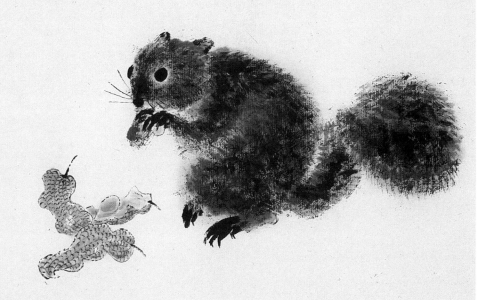

WU GUANZHONG (1919–), Beijing artist.

"Ruins of Gaochang [Turfan]", undated.
 Unsigned, one seal of the artist.
 Mixed media: Chinese ink, pen, and color on paper.

102.7×105.7 cm. (40⅜×41⅝ inches)

吳冠中（1919－），北京畫家。
"高昌遺址"。
沒簽名，有圖章"吳冠中"。
鋼筆水墨設色紙本橫幅。

Plate 39

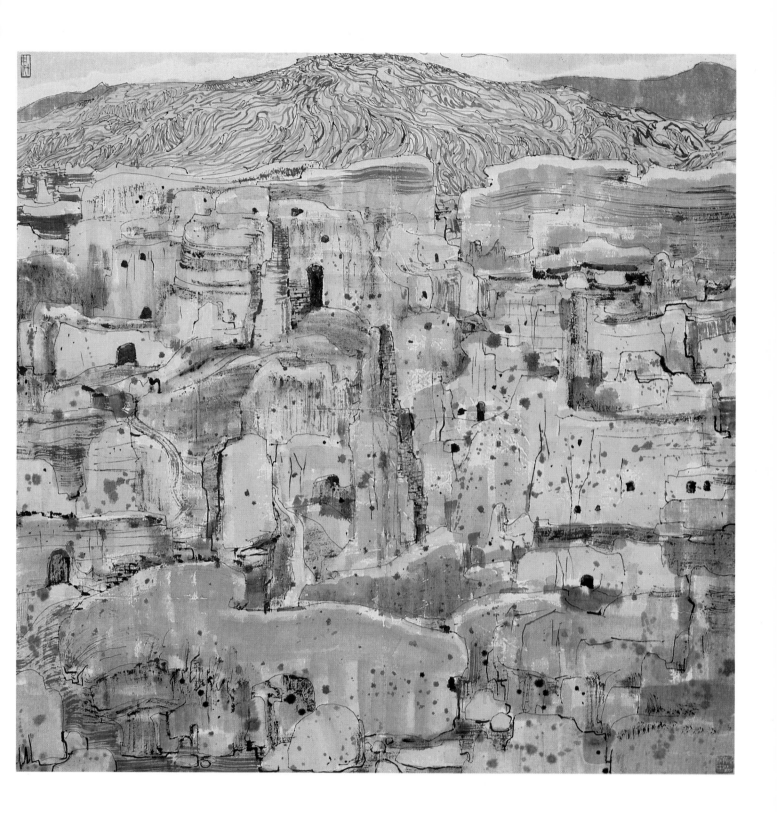

WU GUANZHONG (1919–), Beijing artist.

"Trees", dated April, 1974.
Signed Shu, one seal.
Pen sketch on paper.

39.7 × 27.3 cm. (15⅝ × 10¾ inches)

吳冠中（1919－），北京畫家。
"番字牌"（自題），作於1974年4月。
簽號"茶"，有圖章"冠中寫生"。
鋼筆紙本寫生。

Plate 40

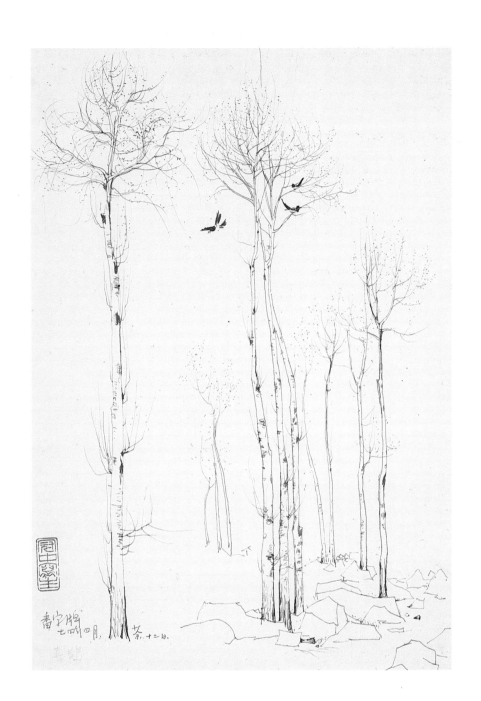

WU GUANZHONG (1919–), Beijing artist.

"Da Yu Island [Zhejiang]", dated 1980.
Signed Shu.
Pen sketch on paper.

26.5 × 37 cm. (10½ × 15⅝ inches)

吳冠中（1919－），北京畫家。
"大魚島"（自題），作於1980年。
簽號"荼"。
鋼筆紙本寫生。

"Western Peak of Huashan", dated 1982.
Signed Shu.
Pen and felt pen sketch on paper.

40 × 29 cm. (15¾ × 11⅜ inches)

吳冠中（1919－），北京畫家。
"華山西峯"（自題），作於1982年。
簽號"荼"。
化學筆紙本寫生。

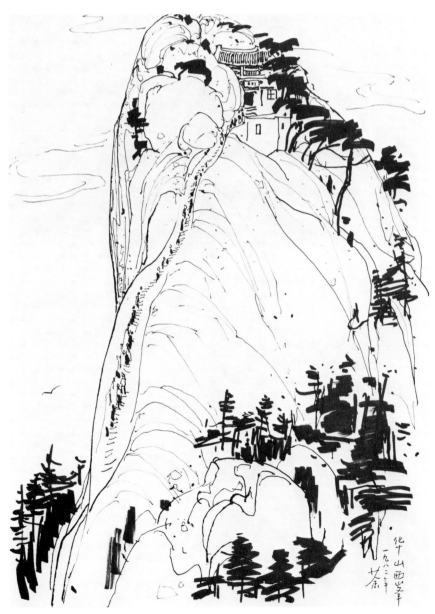

WU ZUOREN (1908–), Beijing artist.

"Herding Camels in Gansu Province", dated *xin you*, 1981.
Signed Zuoren, two seals.
Chinese ink and color on paper.

68 × 136.6 cm. (26¾ × 53¾ inches)

吳作人（1908－），北京畫家。
"河西牧野"（自題），作於辛酉年（1981）。
簽名作人。
水墨設色紙本橫幅。

Plate 43

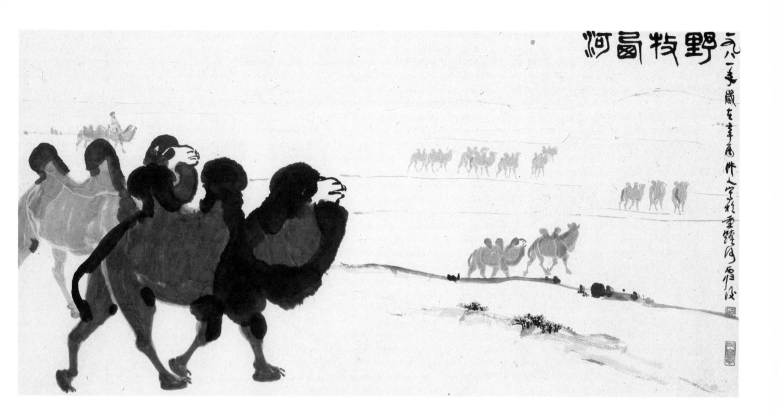

XIAO SHUFANG (1911–), Beijing woman artist.

"Everlasting Spring" (Amaryllises), undated.
Title inscribed by Wu Zuoren (artist's husband) in seal
script.
Signed Xiao Shufang, one seal.
Chinese ink and color on paper.

78 × 48.5 cm. (30¾ × 19 inches)

蕭淑芳（1911－），北京女畫家。
"春長好"（吳作人題）。
簽名蕭淑芳。
水墨設色紙本直幅。

Plate 44

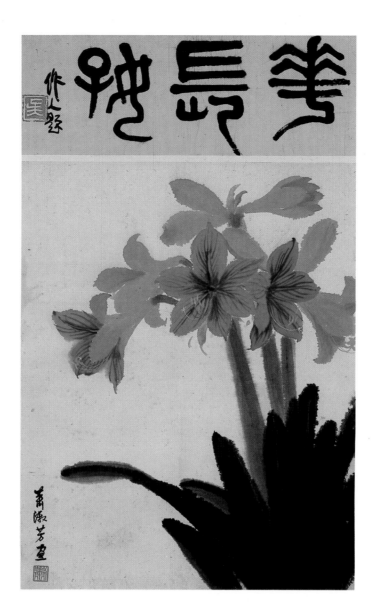

XIE ZHILIU (1909–), Shanghai artist.

"Peony", dated *xin you*, 1981, second month.
Signed Zhiliu, five seals.
Chinese ink and color on paper.

82.5 × 44.2 cm. (32½ × 17⅜ inches)

謝稚柳（1909－），上海畫家。
"牡丹花"，作於辛酉年2月（1981）。
簽名稚柳。
水墨設色紙本直幅。

Plate 45

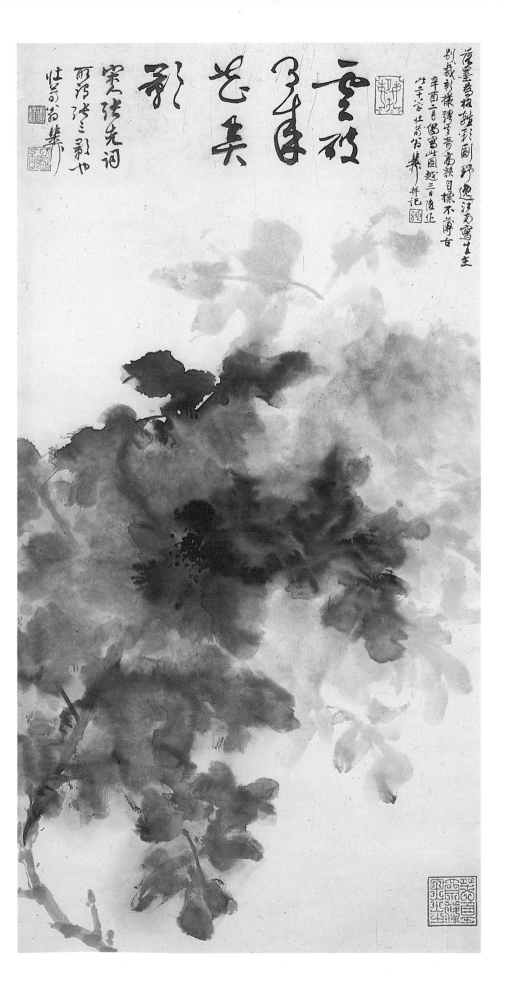

XIE ZHILIU (1909–), Shanghai artist.

"Landscape", undated.
Signed Liu, three seals.
Hanging scroll, Chinese ink and color on paper.

101.5 × 40.8 cm. (40 × 16 inches)

謝稚柳（1909－），上海畫家。
"山水"。
簽名稚柳。
水墨設色紙本立軸。

Plate 46

YA MING (1924–), Nanjing (Jiangsu) artist.

"Yangzi Gorges", dated *xu wu*, 1978, autumn, painted in Beijing.
Signed Ya Ming, four seals.
Hanging scroll, Chinese ink and color on paper.

60 × 69.3 cm. (23⅝ × 27⅛ inches)

亞明（1924－），南京（江蘇）畫家。
"十二巫山見九峯"（自題），戊午年秋
（1978）作於北京。
簽名亞明。
水墨設色紙本立軸。

Plate 47

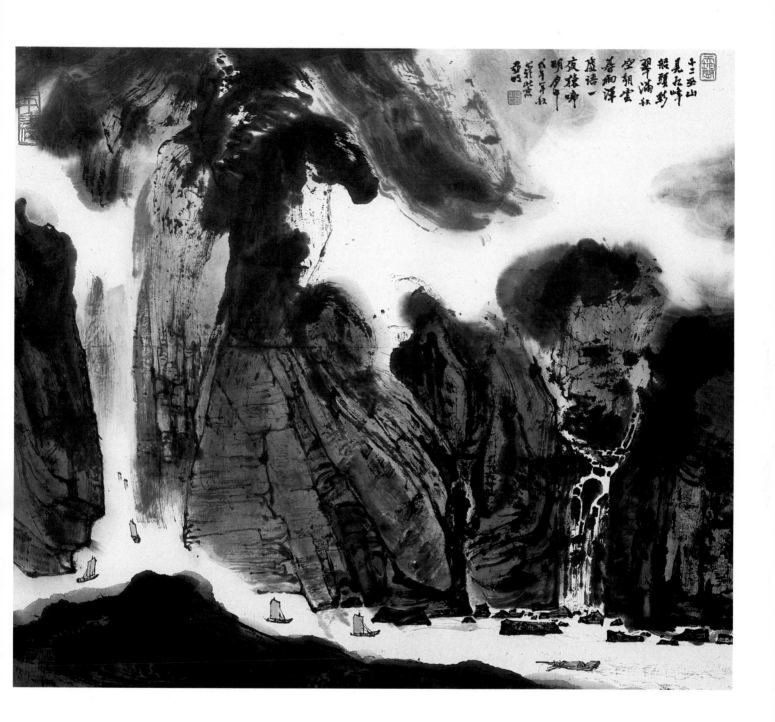

YANG GANG (1946–), Beijing artist.

"Dawn", undated.
Signed Yang Gang, one seal.
Hanging scroll, Chinese ink and color on paper.

41.2×60 cm. (16⅜×23⅝ inches)

楊剛（1946–），北京畫家。
"晨"。
簽名楊剛。
水墨設色紙本立軸。

Plate 48

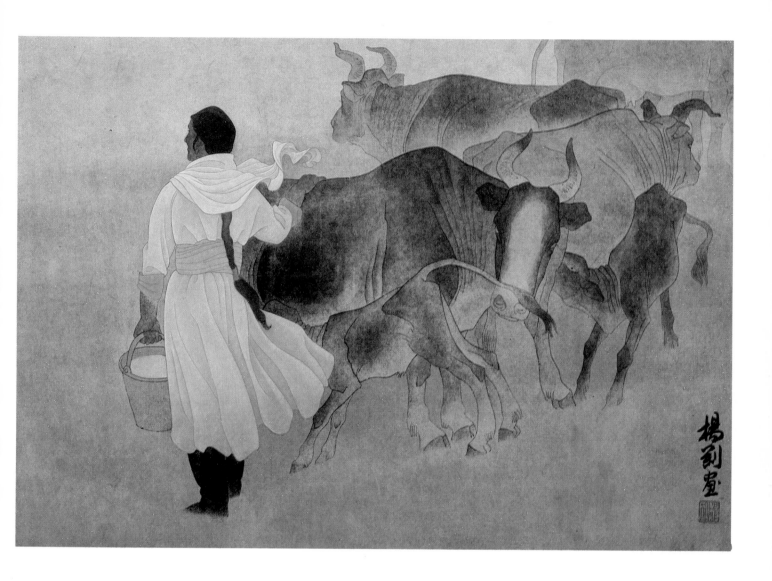

YANG GANG (1946–), Beijing artist.

"Figure", dated *ren xu*, 1982, summer, painted in the town of Xima (Mongolia).
Unsigned, one seal of the artist.
Chinese ink sketch on paper.

45.5×24 cm. (18×9½ inches)

楊剛（1946-），北京畫家。
"人物"，壬戌年夏（1982）作於西馬。
沒簽名，有圖章"楊剛"。
毛筆水墨紙本寫生。

Plate 49

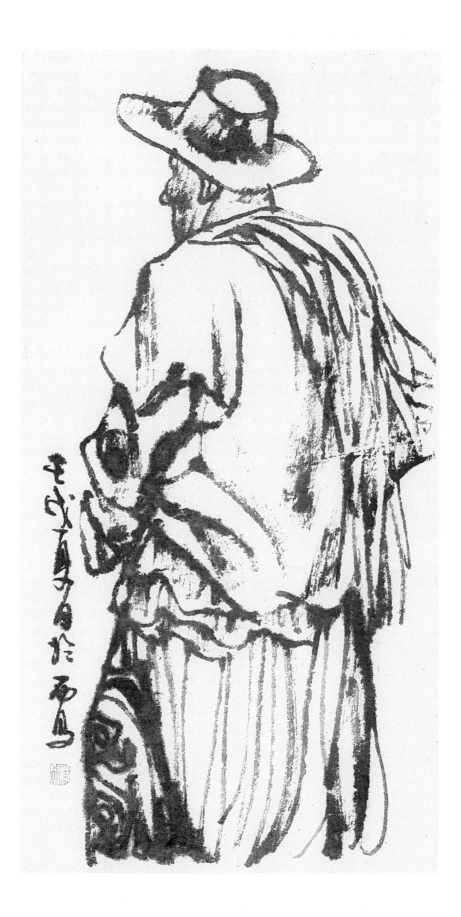

YANG GANG (1946–), Beijing artist.

"Figures", dated 1982, summer, painted at the Nadam Fair in the town of Xima (Mongolia).
Unsigned, one seal of the artist.
Chinese ink sketch on paper.

23 × 33.5 cm. (9 × 13⅛ inches)

楊剛（1946-），北京畫家。
"人物"，1982年夏天作於西馬旗那達幕大會。
沒簽名，有圖章"楊剛"。
毛筆水墨紙本寫生。

"Figures", dated *ren xu*, 1982, autumn.
Unsigned, one seal of the artist.
Chinese ink sketch on paper.

34 × 34 cm. (13⅜ × 13⅜ inches)

"人物"，作於壬戌年秋日（1982）。
沒簽名，有圖章"楊剛"。
毛筆水墨紙本寫生。

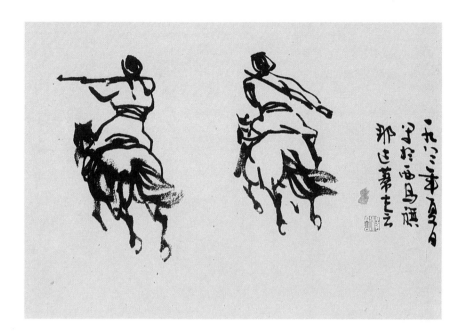

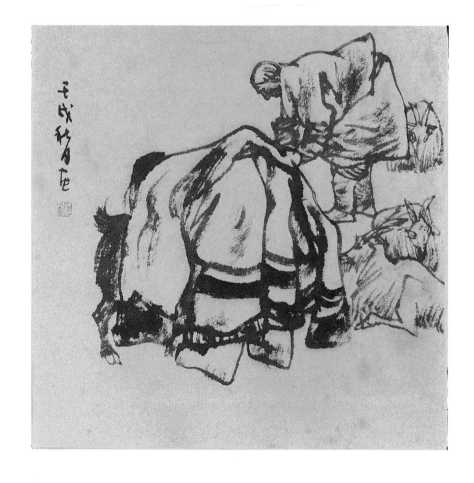

YANG GANG (1946–), Beijing artist.

"Mongolian Wrestlers", dated *ren xu*, 1982.
Unsigned, one seal of the artist.
Chinese ink sketch on paper.

66.7 × 83.7 cm. (26⅜ × 33 inches)

楊剛（1946－），北京畫家。
"蒙古族摔跤手之歌"，作於壬戌年秋月
（1982）。
沒簽名，有圖章"楊剛"。
毛筆水墨紙本寫生。

Plate 52

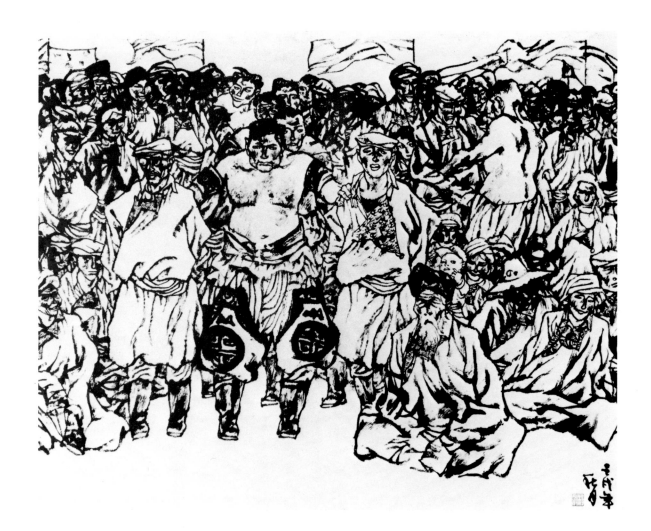

YANG YANPING (1934–), Beijing woman artist.

"Towering Mountain", undated.
Unsigned, seal of the artist.
Hanging scroll, mixed media: Chinese ink, pen, and color
on paper.

67.2×53.2 cm. (26½×21 inches)

楊燕屏（1934–），北京女畫家。
"屹"。
沒簽名，有圖章"屏"。
水墨設色紙本立軸。

Plate 53

ZENG MI (1935–), Hangzhou (Zhejiang) artist.

"Pomo Landscape", undated.
Signed Sanshi (?), two seals.
Hanging scroll, Chinese ink on paper.

91.4 × 40.7 cm. (36 × 16 inches)

曾密（1935－），杭州（浙江）畫家。
"潑墨山水"。
簽名三石二（？）主。
水墨設色紙本立軸。

Plate 54

ZENG SHANQING (1932–), Beijing artist.

"Herdsmen in Snow Storm", undated.
Signed Shanqing, one seal.
Chinese ink and color on paper.

97 × 85.7 cm. (38⅛ × 33¾ inches)

曾善慶（1932－），北京畫家。
"風雪牧人"。
簽名善慶。
水墨設色紙本直幅。

Plate 55

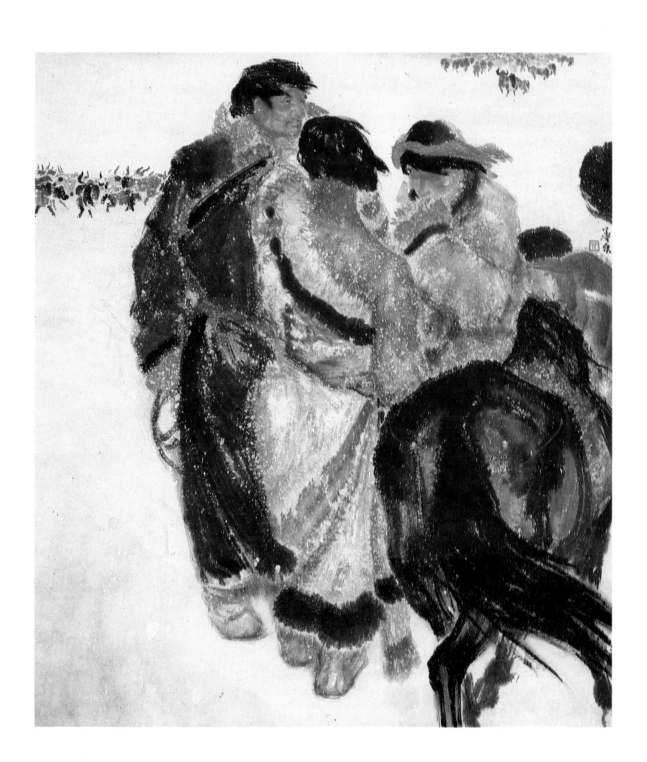

ZHANG BU (1934–), Beijing artist.

"Winter Forest", dated 1980.
Signed Zhang Bu, two seals.
Chinese ink and color on paper.

69.5 × 46.5 cm. (27¼ × 18⅜ inches)

張步（1934－），北京畫家。
"林區之冬"（自題），作於1980年。
簽名張步。
水墨設色紙本直幅。

Plate 56

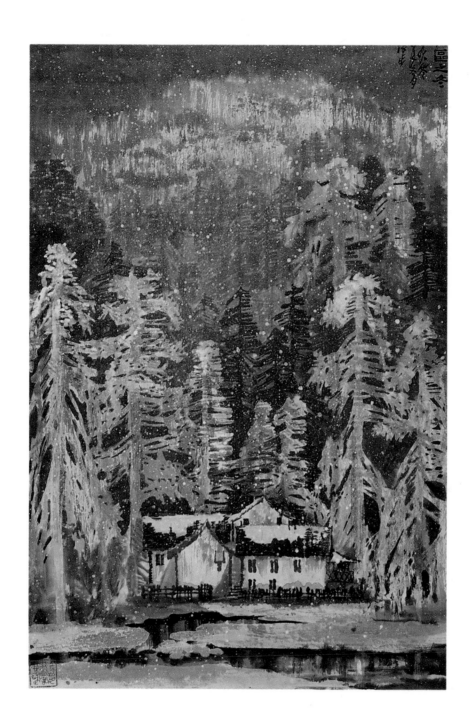

ZHANG BU (1934–), Beijing artist.

"Village", dated 1975.
Signed Zhang Bu, one seal.
Chinese ink and pen sketch on paper.

26 × 25.5 cm. (10¼ × 10 inches)

張步（1934－），北京畫家。
"村頭"（自題），作於1975年。
簽名張步。
鋼筆水墨紙本寫生。

"Clear Stream", undated, painted at Xin Xian, Honan.
Unsigned, one seal of the artist.
Chinese ink, pen, and color sketch.

26.5 × 25.2 cm. (10⅜ × 10 inches)

"清溪"（自題），作於河南新縣。
沒簽名，有圖章"張步"。
鋼筆水墨設色紙本寫生。

Plates 57 and 58

ZHANG BU (1934–), Beijing artist.

"Dawn", undated.
Unsigned, one seal of the artist.
Chinese ink, pen, and color sketch on paper.

25.5×26 cm. (9¼×10⅛ inches)

張步（1934－），北京畫家。
"曙光"（自題）。
沒簽名，有圖章"步"。
鋼筆水墨設色寫生。

Plate 59

ZHAO XIUHUAN (1946–), Beijing woman artist.

"Clear Spring", dated *xin you*, 1981, winter.
Signed Xiuhuan, one seal.
Hanging scroll, Chinese ink, color, and gold on paper.

92 × 45.5 cm. (36¼ × 18 inches)

趙秀煥（1946－），北京女畫家。
"清流"（自題），作於辛酉年冬（1981）。
簽名秀煥。
水墨設色紙本立軸。

Plate 60

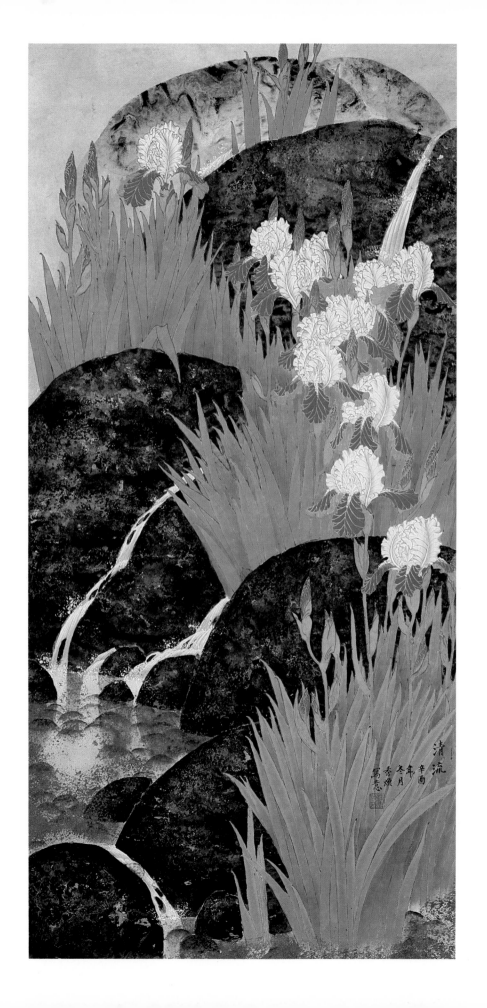

ZHAO XIUHUAN (1946–), Beijing woman artist.

"Mountain Stream", dated *ren xu*, 1982, spring.
Signed Xiuhuan, one seal.
Chinese ink, color, and gold on paper.

133.5 × 88.5 cm. (52⅝ × 34⅞ inches)

趙秀煥（1946－），北京女畫家。
"山溪"（自題），作於壬戌年春（1982）。
簽名秀煥。
水墨設色紙本直幅。

Plate 61

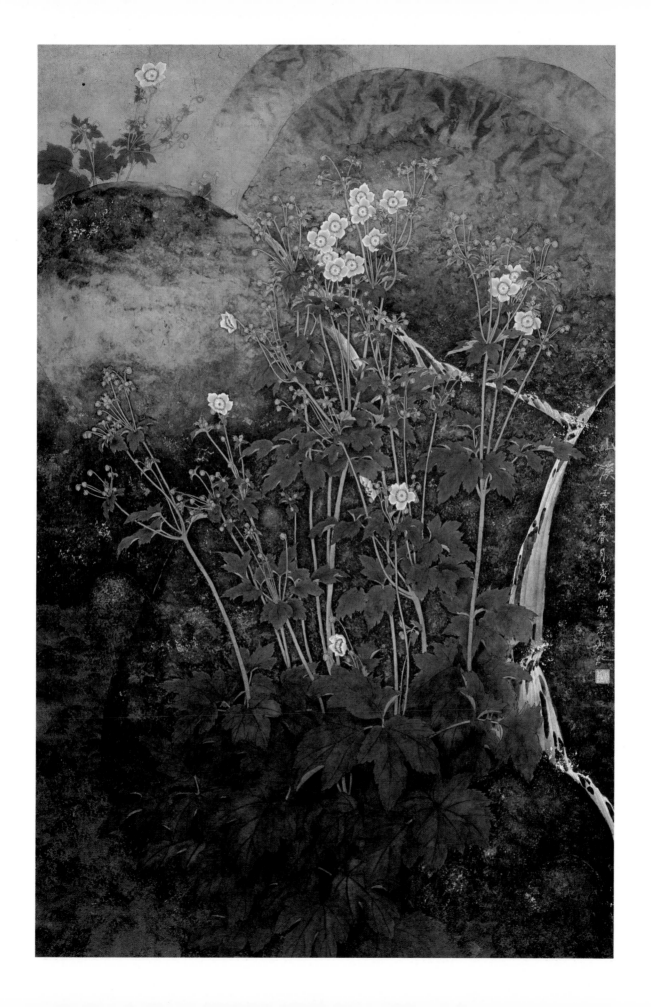

ZHOU CHANGGU (1929–), Hangzhou (Zhejiang) artist.

"Camellia", dated *ren xu*, 1982, painted with the fingernails.
Signed Changgu, three seals.
Fan painting, Chinese ink and color on paper.

27 × 57 cm. (10½ × 22½ inches)

周昌谷（1929－），杭州（浙江）畫家。
"玉泉茶花"（自題），作於壬戌年（1982）。
簽名昌谷。
水墨設色紙本扇面。

Plate 62

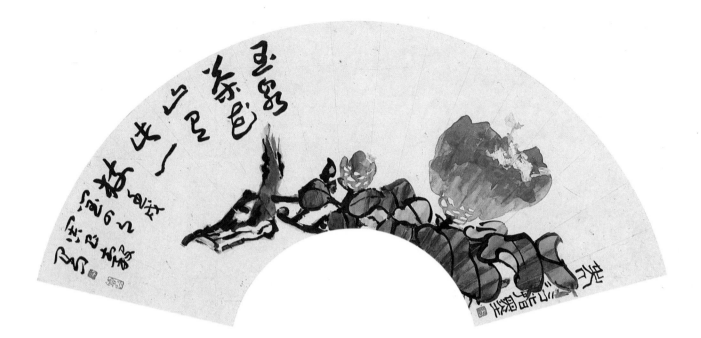

ZHOU SHAOHUA (1929–), Wuhan (Hubei) artist.

"Snow on Minshan [Sichuan Province]", dated 1983.
Signed Shaohua, two seals.
Chinese ink and color on paper.

62.5×97.5 cm. (24⅛×33⅜ inches)

周韶華（1929－），武漢（湖北）畫家。
"岷山雪"（自題），作於1983年。
簽名韶華。
水墨設色紙本橫幅。

Plate 63

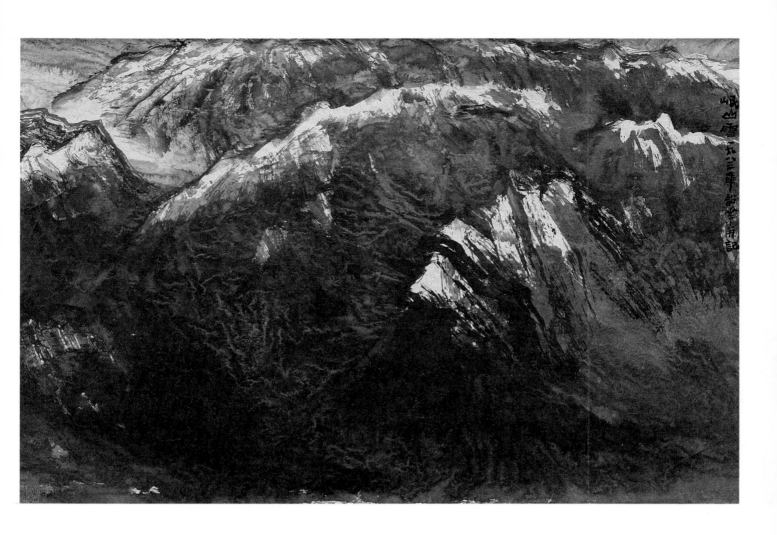

ZHOU SHAOHUA (1929–), Wuhan (Hubei) artist.

"Singing Brook", undated.
Signed Shaohua, two seals.
Chinese ink and color on paper.

85.4 × 69.2 cm. (35½ × 27¼ inches)

周韶華（1929－），武漢（湖北）畫家。
"清清的流水"（自題）。
簽名韶華。
水墨設色紙本直幅。

Plate 64

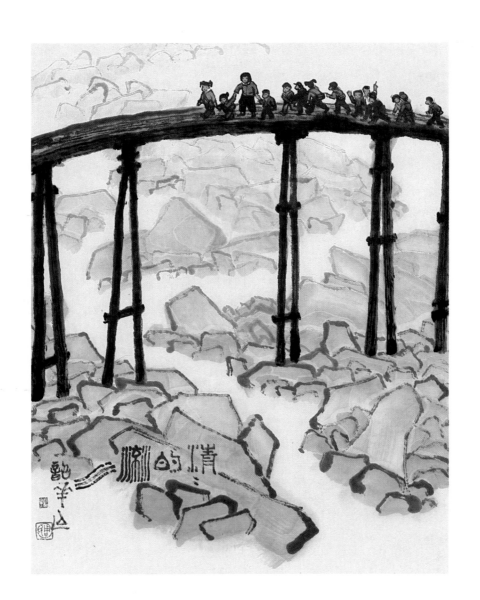

ZHU PEIJUN (1920–), Chengdu (Sichuan) woman artist.

"Baimiao Flowers", ,dated *si wei*, 1979, summer, painted at Spring Dawn Pavilion.
Signed Peijun, two seals.
Chinese ink on paper.

42.5 × 57.5 cm. (16¾ × 22⅝ inches)

朱佩君（1920－），成都（四川）女畫家。
"白描花卉"，己未年初夏（1979）作於春曉閣。
簽名佩君。
白描紙本橫幅。

Plate 65

ZHU QIZHAN (1892–), Shanghai artist.

"Autumn Scene", dated *ding si*, 1979, winter.
Signed Qizhan, two seals.
Hanging scroll, Chinese ink and color on paper.

69 × 68.2 cm. (27⅛ × 26⅞ inches)

朱屺瞻（1892– ），上海畫家。
"山水秋色"，作於丁巳年首冬（1979）。
簽名屺瞻。
水墨設色紙本立軸。

Plate 66

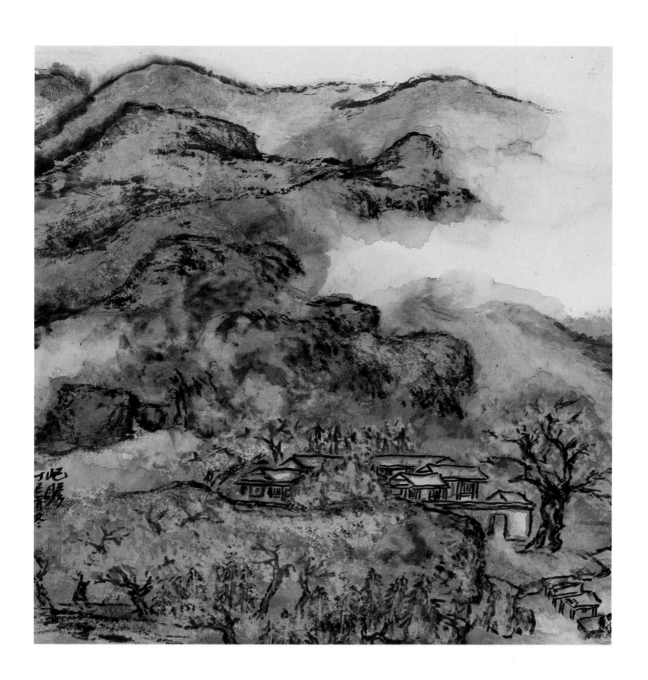

Chinese Artists and Landscapes

Photographs by
Lucy Lim and Kit Luce

The Yangzi Gorges

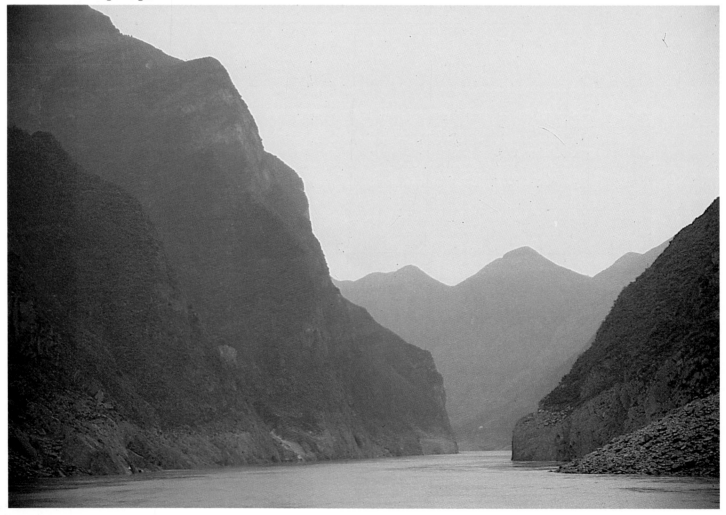

Zhao Xiuhuan

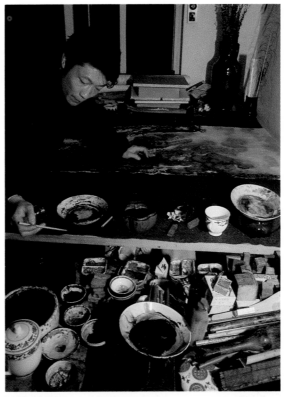

Li Huasheng

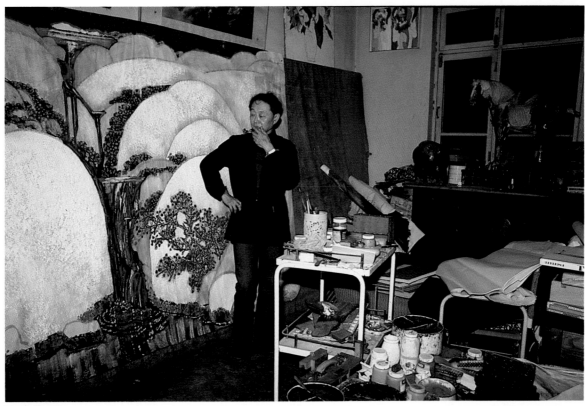

Huang Yongyu

Lu Yanshao

Li Keran

Wu Zuoren and Xiao Shufang

Artist writing calligraphy

Artist painting in the *pomo* "splashed-ink" manner

Serrated rock forms of the mountain cliffs alongside the Yangzi River

Biographical Data on the Artists

Translated from the Chinese list compiled by the Chinese Artists' Association.

CHEN PEIQIU
Shanghai woman artist

1922	Born
1950	Graduated from Hangzhou National Arts College
1956	Placed first in the "Shanghai Youths Art Exhibition" and second in the "National Arts Exhibition"
1956	Participated in the Second National Arts Exhibition
1962	Participated in the Third National Arts Exhibition
1964	Participated in the Fourth National Arts Exhibition
1979	Participated in the Fifth National Arts Exhibition

CHENG SHIFA
Shanghai artist

1921	Born
1941	Graduated from Shanghai Arts College
1941	Solo exhibition in Shanghai
1957	Solo exhibition "Sketches of Yunnan" held in Shanghai
1959	Received Silver Award for book illustrations at the Laibixi International Book Awards
1980	Solo exhibition in Tokyo

CUI ZIFAN
Beijing artist

1915	Born Studied traditional Chinese painting independently and also under Qi Baishi
1980	Participated in the Chinese (International) Fair held in the United States and Japan
1981	Solo exhibition held in Zhangchun, Harbin
1981	Participated in the "Exhibition of Painting from the Beijing Painting Academy" held in Canada
1981	Participated in the "Joint Exhibition of the Beijing and Shanghai Painting Academies"
1981	Placed first for Outstanding Artwork in Beijing
1982	Solo exhibitions in Beijing, Jinan, and Yantai

FANG JIZHONG

Vice Chairman of the Shaanxi Regional Branch of the Chinese Artists' Association
Director of the Shaanxi Painting Academy

1923	Born
1946-47	Studied traditional Chinese painting independently and also under Zhao Wangyun
1958	Participated in a group exhibition of Chinese paintings held in Vienna
1961	Participated in the "Group Exhibition of Six Artists: Shi Lu, Zhao Wangyun, He Haixia, and Fang Jizhong" held in Beijing, Nanjing, Shanghai, and Hangzhou
1981	Solo exhibition in Jinan, Shandong Province
1981	Participated in the Spring Salon Exhibition in France

FANG ZENGXIAN

Associate Professor at the Zhejiang Art Academy

1931	Born
1953	Graduated from Zhejiang Art Academy Participated in many regional exhibitions

GUAN LIANG

Professor at the Zhejiang Art Academy
Vice Chairman of the Shanghai Branch of the Chinese Artists' Association

1900	Born
1922	Graduated in Western painting from the Pacific Art Institute in Tokyo
1942	Solo exhibition in Chongqing
1957	Exhibition of paintings by Guan Liang and Li Keran
1960	Solo exhibition in Nanjing
1981	Solo exhibition in Hong Kong
1982	Solo exhibition in Shanghai

GUAN SHANYUE

Vice Chairman of the Chinese Artists' Association
Chairman of the Guangdong Regional Branch of the Chinese Artists' Association
Associate Director and Professor of the Guangzhou Art Academy

1912	Born
1936-39	Studied traditional Chinese painting under Gao Jianfu
1940	Participated in the "Exhibition of Chinese Fine Arts" held in the Soviet Union
1958	Participated in the "Exhibition of Socialist Art" held in Moscow
1982	Solo exhibition in Japan Exhibited frequently in national exhibitions in China and abroad

HUANG YONGYU

Professor at the Central Art Academy, Beijing

1924	Born
1979	Solo exhibition held in Beijing
1980	Group exhibition of "Four Artists" held in the Philippines
1983	Solo exhibition in Hong Kong Exhibited frequently in national exhibitions in China and abroad

LI GENG

Beijing artist

1950	Born Studied traditional Chinese painting from his father, Li Keran
1980-present	Studying painting at Tokyo University of Art
1982	Solo exhibition in Japan
1983	Solo exhibition in Japan

LI HUASHENG

Chongqing (Sichuan) artist

1944	Born
1954-76	Studied traditional Chinese painting under Chen Zizhuang
1980	Participated in the "Exhibition of Chinese Modern Calligraphy and Painting" held in Singapore
1981	Participated with ten artists in the exhibition "Landscape Painting" held in Beijing
1981	Participated in the "Exhibition of Chinese Modern Calligraphy and Painting" held in Singapore
1981	Received Outstanding Artwork Award in Sichuan Province

LI KERAN

Professor at Central Art Academy, Beijing
Vice Chairman of the Chinese Artists' Association
Honorary President of the Beijing Landscape Painting Research Association

1907	Born in Xuzhou in Jiangsu Province
1925	Graduated from Shanghai Arts College
1931	Graduated from the Research Department at the National Xihu Art Academy Entered the "18 Artists Association", a youth art organization cultivated by Lu Xun
1932-37	Appointed instructor at a private junior arts college in Xuzhou
1943-46	Instructor at Chongqing National Junior Arts College
1946-49	Associate Professor in traditional Chinese painting at the National Beijing Arts College
1957	"Painting Exhibition—Li Keran, Guan Liang" held in Dongboli
1959	Solo exhibition touring eight major cities including Beijing
1959	Solo exhibition in Xilage
1962	Participated in Third National Arts Exhibition
1964	Participated in Fourth National Arts Exhibition
1979	Participated in Fifth National Arts Exhibition
1979	"Exhibition of Li Keran and His Major Followers" held in Japan

LI KUCHAN

Professor of the Central Art Academy, Beijing

1898-1983

1925	Graduated from the Beijing National Arts College Studied drawing from Xu Beihong and traditional Chinese painting from Qi Baishi
1935-40	Solo exhibition in Tianjin and Jinan
1946	Solo exhibition in Beijing
1949-83	Participated in successive national art exhibitions
1951-83	Participated in successive painting exhibitions held by the Chinese Painting Research Institute in Beijing
1980	"Exhibition of Painting and Calligraphy by Father and Son, Li Kuchan and Li Yen" held in Hong Kong
1981	"Exhibition of Painting and Calligraphy by Father and Son, Li Kuchan and Li Yen" held in Guilin Exhibited abroad on several occasions

LI WENHAN
Beijing Artist

1937	Born
1963	Graduated from Central Art Academy, Beijing
1978	Participated in the "Group Exhibition of Six Artists from the Beijing Painting Academy" held in Hong Kong
1980	Solo exhibition in Hong Kong
1980	Participated in the "Joint Exhibition of the Beijing and Nanjing Painting Academies"
1980	Received Outstanding Artwork Award in Beijing
1981	Participated in the "Exhibition of Works from the Beijing Painting Academy" held in Canada
1981	Participated in the "Joint Exhibition of the Beijing and Shanghai Painting Academies"
1981	Placed third for Outstanding Artwork in Beijing
1982	Participated in the "Joint Exhibition of the Beijing and Japan Painting Academies"

LIU HAISU
Director and Professor of the Nanjing Art Academy

1896	Born Studied painting independently	1980	Solo exhibition in Shanghai
		1981	Solo exhibition in Hong Kong
1922	Solo exhibition in Beijing	1982	Solo exhibition in Nanjing
1927	Solo exhibition in Tokyo	1983	Solo exhibitions in Shanghai and Beijing
1928	Solo exhibition in Shanghai		
1930	Received International Honor in Belgium for traditional Chinese painting		
1931	Solo exhibition in Paris		
1932	Solo exhibition in Shanghai		
1933	Solo exhibition in Nanjing		
1934	Solo exhibition in Paris		
1936	Solo exhibitions in Shanghai and Qingdao		
1947	Solo exhibition in Shanghai		
1948	Solo exhibition in Taibei		
1957	Solo exhibition in Shanghai		
1979	Solo exhibitions in Beijing and Nanjing		

LIU LUN
Guangzhou artist
Director of the Guangzhou Art Academy

1913	Born
1931	Graduated from Guangzhou Shili Arts Institute
1964	Received award for Outstanding Artwork in the "Third Exhibition of the Chinese People's Liberation Army"
1979	Participated in the "Exhibition of Traditional Chinese Painting" held in the United States
1980	Solo exhibition held in Guangdong
1981	Participated in the "Inaugural Exhibition of the Chinese Painting Research Institute"
1981	Placed second for Outstanding Artwork in Guangdong

LU YANSHAO
Professor at the Zhejiang Art Academy

1909	Born
1927	Studied traditional Chinese painting under Feng Chaoran
1931-40	Solo exhibitions held in Chongqing, Chengdu, Leshan, and Yibin, Sichuan Province
1947	Solo exhibition held in Wuxi
1979	Placed third in the "Exhibition of Paintings in Celebration of the Thirtieth Anniversary of the Founding of the People's Republic of China"
1980	Solo exhibition held in Beijing
1981	Solo exhibition held in Hong Kong Exhibited frequently in national exhibitions in China and abroad

NIE OU
Beijing woman artist

1948	Born
1981	Graduated from the Central Art Academy in traditional Chinese painting
1981	Participated in the "Joint Exhibition of the Beijing and Shanghai Painting Academies"
1981	Participated in the "Exhibition of Works from the Beijing Painting Academy" held in Canada
1981	Placed second for Outstanding Artwork in Beijing
1982	Participated in the exhibition "Springtime in Beijing" held in Beijing
1982	Participated in the "Joint Exhibition of the Beijing and Japan Painting Academies"

PENG PEIQUAN
Beijing artist

1941	Born
1967	Graduated in traditional Chinese painting from the Central Art Academy
1979	Participated in the "Joint Exhibition of Paintings from Beijing and Nanjing"
1979	Participated in the "Exhibition of Traditional Chinese Painting" held in San Francisco
1980	Placed first for Outstanding Artwork in Beijing
1981	Participated in the "Exhibition of Paintings from the Beijing Painting Academy" held in Canada
1982	Participated in the "Joint Exhibition of the Beijing and Japan Painting Academies"
1982	Placed third for Outstanding Artwork in Beijing

SHAO FEI
Beijing woman artist

1954	Born Studied traditional Chinese painting independently
1975	Participated in the "Art Exhibition of the Chinese People's Liberation Army"
1975, 76, 79	Participated in the "Beijing Art Exhibition"
1978	Participated in the "Group Exhibition of the Beijing Painting Academy
1981	Participated in the "Joint Exhibition of the Beijing and Shanghai Painting Academies"
1982	Participated in "National Youth Art Exhibition" and the "Exhibition of the Beijing Painting Academy in Canada"
1983	Participated in "Joint Exhibition of the Beijing and Japan Painting Academies"

SONG WENZHI

Associate Director of the Jiangsu Chinese Painting Academy
Vice Chairman of the Jiangsu Regional Branch of the Chinese Artists' Association

1919	Born Studied at Suzhou Arts College Studied traditional painting under Wu Hufan and Zhang Shiyuan
1979	Participated in the "Exhibition of Eight Artists of the Jinling School" held in Hong Kong
1980	Participated in the "Exhibition of Paintings from the Jiangsu Painting Academy" held in Japan
1981	Solo exhibition in Tokyo
1981	Solo exhibition in Beijing
1982	Solo exhibition in Nanjing
1982	Participated in the Spring Salon Exhibition in France

TANG YUN

Acting Director of the Shanghai Painting Academy
Vice Chairman of the Shanghai Branch of the Chinese Artists' Association

1910	Born Studied traditional Chinese painting independently
1942	Solo exhibition in Shanghai
1944	Group exhibition "Cup of Water" in Shanghai
1947	Solo exhibition in Shanghai
1951	Solo exhibition in Hong Kong
1963	Participated in the "Group Exhibition of Flower and Bird Paintings from Shanghai" held in Beijing Participated in many regional and national exhibitions

WU GUANZHONG

Professor of the Central Arts and Crafts Academy, Beijing

1919	Born
1942	Graduated from the Hangzhou National Art Academy Studied under Pan Tianshou
1947-50	Studied at Professor Souverbie's studio at the Paris National Arts Institution of Higher Learning
1948-49	Participated at the Spring Salon Exhibition in France
1979	Solo exhibitions in Beijing, Shenyang, Taiyuan, Zhongqing and Changsha
1979	Participated in the Asian art exhibition held in Japan
1980	Solo exhibitions in Tianjin, Hangzhou, Guilin
1981	Placed third for Outstanding Artwork in Beijing
1981	Solo exhibition in Beijing
1981	"Group Exhibition—Zhan Jianjun, Liu Huanzhang, Wu Guanzhong" held in Nigeria, Mali and Sierra Leone
1982-83	Participated in the exhibition "2500 Years of Chinese Culture" held in Tokyo
1982	Participated in the Spring Salon Exhibition in France
1983	Participated in the "Joint Exhibition of the Beijing and Japan Painting Academies"
1983	Solo exhibition in Nanjing

WU ZUOREN

Vice Chairman of the Chinese Federation of Literature and Art
Acting Chairman of the Chinese Artists' Association
Professor at the Central Art Academy, Beijing

1908	Born
1927	Studied Western painting at Shanghai College of Arts
1928-29	Studied art at South Shanghai Arts Academy and the Nanjing Central University – Studied at Xu Beihong's studio
1930-34	Studied at Simon Arts Institution of Higher Learning in Paris and the Bastien Arts Academy in Belgium
1936	Participated in the "Group Exhibition of Three Painters Featuring Painter Lu Sibai, Sculptor Liu Kaiqu, and Painter Wu Zuoren"
1945	Solo exhibition and "Exhibition of Frontier Paintings" held in Chengdu
1946	"Exhibition of Frontier Paintings" held in Shanghai
1947	Solo exhibition at the "China Institute" in London, England
1941-83	Exhibited in national and international art exhibitions

XIAO SHUFANG

Beijing woman artist
Associate Professor at Central Art Academy, Beijing

1911	Born
1926-30	Studied art at Beijing National Arts and Nanjing Central University Studied at Xu Beihong's studio
1937-40	Studied watercolor and sculpture in England
1949	Participated in the First National Arts Exhibition
1956	Participated in the Second National Arts Exhibition
1962	Participated in the Third National Arts Exhibition
1964	Participated in the Fourth National Arts Exhibition
1979	Participated in the Fifth National Arts Exhibition Exhibited frequently in international exhibitions

XIE ZHILIU

Shanghai artist
Vice Chairman of the Shanghai Branch of the Chinese Artists' Association

1909	Born Studied traditional Chinese painting independently
1942	Solo exhibition in Chengdu
1943	Solo exhibition in Chongqing
1944	Solo exhibition in Kunming
1945	Solo exhibition in Xi'an
1946	Solo exhibition in Shanghai
1961	Solo exhibition in Beijing
1963	Solo exhibition in Guangzhou
1979	Participated in the "Joint Exhibition of Calligraphy from Daban and Shanghai" held in Japan

YA MING
Chairman of the Jiangsu Branch of the Chinese Artists' Association
Associate Director of the Jiangsu Chinese Painting Academy

1924	Born
1942	Graduated from Huainan Arts College
1980	Participated in the "Group Exhibition of Eight Artists from Jiangsu Painting Academy" held in Hong Kong
1981	Participated in the "Group Exhibition of the Jiangsu Painting Academy" held in Japan
1981	Solo exhibition in the city of Hefei
1982	"Joint Exhibition—Ya Ming, Song Wenzhi" held in Singapore
1983	Solo exhibition held in Fuzhou Exhibited abroad on many occasions

YANG GANG
Beijing artist

1946	Born
1981	Graduated from the Central Art Academy
1982	Participated in the exhibition "Springtime in Beijing" held in Beijing
1982	Participated in the "Joint Exhibition of the Beijing and Shanghai Painting Academies"
1982	Participated in the "Joint Exhibition of the Beijing and Japan Painting Academies" held in Beijing
1982	Placed third in the exhibition "Springtime in Beijing"

YANG YANPING
Beijing woman artist

1934	Born
1958	Graduated in architecture from Qinghua University Studied traditional Chinese painting independently
1979	Participated in the "Joint Exhibition of Paintings from Beijing and Tokyo"
1979	Participated in the "Exhibition of Paintings in Celebration of the Thirtieth Year Anniversary of the Founding of the People's Republic of China"
1981	"Group exhibition of four artists—Zeng Shanqing, Wang Naizhuang, Li Xiushi, Yang Yanping"
1982	Participated in the Spring Salon Exhibition in France

ZENG MI
Hangzhou artist

1935 Born

1962 Graduated from Zhejiang Art Academy in traditional Chinese painting

1958 Solo exhibition in Moscow

1982 "Exhibition of Traditional Chinese Painting from Zhejiang Province" held in Beijing

ZENG SHANQING
Associate Professor in the Traditional Painting Department of the Central Art Academy, Beijing

1932 Born

1950 Graduated from the Central Art Academy in oil painting

1951 Graduated from the Research Department at the Central Art Academy
 Studied under Xu Beihong

1963 Participated in numerous group exhibitions held in Beijing

1981 "Group Exhibition of Four Artists—Li Xiushi, Wang Naizhuang, Zeng Shanqing, Yang Yanping"

1981 Participated in group exhibitions held in Tokyo and Hong Kong

1982 Participated in a group exhibition held in Hefei

ZHANG BU
Beijing artist

1934 Born

1963 Graduated from the Central Art Academy
 Studied traditional Chinese painting under Li Keran

1979 "Joint Exhibition—Li Keran and His Followers"

1980 Solo exhibition in Tokyo

1980 Placed first for Outstanding Artwork in Beijing

1981 Participated with ten artists in the exhibition "Landscape Painting" held in Beijing
 Placed second for Outstanding Artwork in Beijing

1982 Solo exhibition held at the Beijing Hotel Art Gallery
 Solo exhibition held at Tangshan

1983 Group exhibition with nine artists entitled "Scenes of Beijing" held in Beijing
 Exhibited abroad on several occasions

ZHAO XIUHUAN
Beijing woman artist

1946 Born

1967 Graduated from middle school affiliated with the Central Art Academy

1979 Participated in the "Joint Exhibition of Paintings from Tokyo and the Beijing Painting Academy"

1980 Placed third in the "National Youth Art Exhibition"

1981 Participated in "Exhibition of the Beijing Painting Academy held in Canada"

1982 Participated in the "Joint Exhibition of the Beijing and Japan Painting Academies"

ZHOU CHANGGU
Associate Professor in the Painting Department of the Zhejiang Art Academy

1929 Born

1953 Graduated from the Zhejiang Art Academy

1955 Golden Award at Global Youth Festivities

1982 Solo exhibition in Hangzhou

1982 "Joint Exhibition—Zhou Changgu and Zhu Hanlian" held in Shenjun

1982 "Group Exhibition—Zhou Changgu, Huang Huanwu, Xiao Huirong" held in the Assembly Hall at Hong Kong

1982 Participated in group exhibitions in Hong Kong

ZHOU SHAOHUA
Director of the Hubei Art Academy
Vice Chairman of the Hubei Regional Branch of the Chinese Artists' Association

1929 Born

1950 Graduated in Fine Arts from the Literature and Arts Academy of Zhongyuan University

1979 Received Outstanding Artwork Award from Hubei Province

1981 Participated in the "Chinese Painting Exhibition of Ten Artists from Hubei" held in Wuhan, Chongqing, Chengdu, and Beijing

1981 Received Outstanding Artwork award from Hubei Province

1982 Participated in the "Joint Exhibition of the Qingchuan Painting Association and the Shen Society" held in Wuhan, Xi'an, Tianjin, and Fuzhou

ZHU PEIJUN

Chengdu (Sichuan) woman artist
Associate Director of the Chengdu Painting Academy
Vice Chairman of the Sichuan Regional Branch of the Chinese Artists' Association

1920	Born
1958	Placed third in the "National Youth Painting Exhibition"
1980	Participated in the "Group Exhibition of Four Artists—Traditional Chinese Painting" in Chengdu
1981	Received Outstanding Artwork award from Sichuan Province

ZHU QIZHAN

Shanghai artist
Professor at Hua Dong Shifan University

1892	Born
1930	Studied Western painting in Japan Studied traditional Chinese painting independently
1962	Solo exhibitions in Shanghai, Nanjing, and Xi'an
1980	Participated in group exhibitions held in Japan
1982	Solo exhibitions in Shanghai, Nanjing, Beijing and Chengdu
1982	Solo exhibition in Guangzhou
1982	Participated in the Spring Salon Exhibition held in France
1982	Participated in group exhibitions in the United States and India

畫家簡歷

陳佩秋（女）
上海畫家
1922年　出生
1950年　畢業於杭州國立藝術專科學校
1956年　上海青年美術展覽一等獎、全國美術作品展覽二
　　　　等獎
1956年　全國第二次美術作品展
1962年　全國第三次美術作品展
1964年　全國第四次美術作品展
1979年　全國第五次美術作品展

程十髮
上海畫家
1921年　出生
1941年　畢業於上海美術專科學校
1941年　在上海舉辦個展
1957年　在上海舉辦《雲南寫生》個展
1959年　獲萊比錫國際書籍裝幀插圖銀質獎
1980年　在日本東京舉辦個展

崔子范
北京畫家
1915年　出生
　　　　自學國畫，曾從齊白石先生學習國畫
1980年　參加在美國、日本舉辦的中國博覽會
1981年　在長春、哈爾濱舉辦個展
1981年　參加在加拿大舉辦的《北京畫院作品展》
1981年　參加《北京畫院與上海畫院聯展》
1981年　獲北京市優秀美術作品一等獎
1982年　在北京、濟南、烟台舉辦個展

方濟衆
中國美術家協會陝西省分會副主席
陝西省國畫院院長
1923年　　　　出生
1946〜47年　自學國畫，曾從師趙望雲先生習畫
1958年　　　　參加在維也納舉辦的中國畫聯展
1961年　　　　參加在北京、南京、上海、杭州舉辦的《石魯、
　　　　　　　趙望雲、何海霞、方濟衆等六人聯展》
1981年　　　　在山東省濟南舉辦個人畫展
1982年　　　　參加法國春季沙龍展

方增先
浙江省美術學院副教授
1931年　出生
1953年　畢業於浙江美術學院
　　　　曾多次參加地方聯展

關　良
浙江省美術學院教授
中國美術家協會上海市分會副主席
1900年　出生
1922年　畢業於日本東京太平洋美術學校西畫科
1942年　在重慶舉辦個展
1957年　在東德柏林舉辦《關良、李可染畫展》
1960年　在南京舉辦個展
1981年　在香港舉辦個展
1982年　在上海舉辦個展

關山月
中國美術家協會副主席
中國美術家協會廣東省分會主席
廣州美術學院副院長，教授
1912年　　　　出生
1936〜1939年　從高劍父先生學習國畫
1940年　　　　參加在蘇聯舉辦的《中國美術展覽》
1958年　　　　參加在莫斯科舉辦的《社會主義造型藝術展覽》
1982年　　　　在日本舉辦個展
　　　　　　　作品經常參加全國性美展及國外聯展

黃永玉
中央美術學院教授
1924年　出生
1979年　在北京舉辦個展
1980年　在菲律賓舉辦《四人聯展》
1983年　在香港舉辦個展
　　　　多次參加全國性美展及國外聯展

李　庚
北京畫家
1950年　　　　出生
　　　　　　　從父李可染先生學習國畫
1980年〜至今　在日本京都藝術大學學習繪畫
1982年　　　　在日本舉辦個展
1983年　　　　在日本舉辦個展

李華生
四川省畫家
1944年　　　　出生
1954～1976年　曾從陳子庄先生學習國畫
1980年　　　　參加在新加坡舉辦的《中國現代書畫展》
1981年　　　　參加在北京舉辦的《河山如畫》十人聯展
1981年　　　　參加在新加坡舉辦的《中國現代書畫展》
1981年　　　　獲四川省優秀美術作品獎

李可染
中央美術學院教授、中國美術家協會副主席
北京山水畫研究會名譽會長
1907年　　　　出生於江蘇省徐州市
1925年　　　　畢業於上海美術專科學校
1931年　　　　畢業於國立西湖藝術院研究部
　　　　　　　同年加入魯迅先生培育的進步青年美術團體"一八
　　　　　　　藝社"
1932～1937年　在徐州私立藝術專科學校任教
1943～1946年　在重慶國立藝術專科學校任教
1946～1949年　在國立北平藝專任國畫系副教授
1957年　　　　在東柏林舉辦《李可染、關良畫展》
1959年　　　　在北京等八大城市巡廻個展
1959年　　　　在布拉格舉辦個展
1962年　　　　第三次全國美展
1964年　　　　第四次全國美展
1979年　　　　第五次全國美展
1979年　　　　在日本舉辦《李可染及其高徒展覽》

李苦禪
中央美術學院教授（1983年6月去世）
1898年　　　　出生
1925年　　　　畢業於北平國立藝術專科學校，曾從徐悲鴻先生
　　　　　　　學習素描，從齊白石先生學習國畫
1935～1940年　在天津、濟南多次舉辦個展
1946年　　　　在北京舉辦個展
1949～1983年　參加歷屆全國美術作品展
1951～1983年　在北京參加中國畫研究會舉辦的歷屆畫展
1980年　　　　在香港舉辦《李苦禪、李燕父子書畫展》
1981年　　　　在桂林舉辦《李苦禪、李燕父子書畫展》
　　　　　　　作品多次參加國外展出

李間漢
北京畫家
1937年　出生
1963年　畢業於中央美術學院
1978年　參加在香港舉辦的《北京畫院六人聯展》
1980年　在香港舉辦個展
1980年　參加《北京畫院、南京畫院聯展》
1980年　獲北京市優秀美術作品獎
1981年　參加在加拿大舉辦的《北京畫院作品展》
1981年　參加《北京畫院、上海畫院聯展》
1981年　獲北京市優秀美術作品三等獎
1982年　參加《中國北京畫院、日本南畫院聯展》

劉海粟
南京藝術學院院長、教授
1896年　　　　出生
　　　　　　　自學國畫
1922年　　　　在北京辦個展
1927年　　　　在日本東京舉辦個展
1928年　　　　在上海舉辦個展
1930年　　　　國畫作品獲比利時國際榮譽獎
1931年　　　　在法國巴黎辦個展
1932年　　　　在上海舉辦個展
1933年　　　　在南京舉辦個展
1934年　　　　在法國巴黎舉辦個展
1936年　　　　在上海、青島舉辦個展
1947年　　　　在上海舉辦個展
1948年　　　　在台北舉辦個展
1957年　　　　在上海舉辦個展
1979年　　　　在北京、南京舉辦個展
1980年　　　　在上海舉辦個展
1981年　　　　在香港舉辦個展
1982年　　　　在南京舉辦個展
1983年　　　　在上海、北京舉辦個展

劉侖
廣東省畫家
廣州畫院院長
1913年　出生
1931年　畢業於廣州市立美術學校
1964年　獲《中國人民解放軍第三屆美術作品展》優秀獎
1979年　參加在美國展出的《中國國畫展》
1980年　在廣州舉辦個展
1981年　在北京、廣州參加《中國畫研究院第一屆畫展》
1981年　獲廣東省優秀美術作品二等獎

陸儼少
浙江省美術學院教授
1909年　　　　出生
1927年　　　　曾從馮超然先生學習國畫
1931～1940年　在重慶、成都、四川省樂山、宜賓舉辦個展
1947年　　　　在無錫舉辦個展
1979年　　　　獲《中華人民共和國建國三十週年畫展》
　　　　　　　三等獎
1980年　　　　在北京舉辦個展
1981年　　　　在香港舉辦個展
　　　　　　　多次參加全國及地方聯展、國外聯展

聶歐（女）
北京畫家
1948年　出生
1981年　畢業於中央美院中國畫系研究生班
1981年　參加《北京畫院與上海畫院聯展》
1981年　參加在加拿大舉辦的《北京畫院作品展》
1981年　獲北京市優秀美術作品二等獎
1982年　參加在北京舉辦的《北京之春》畫展
1982年　參加《中國北京畫院、日本南畫院聯展》

彭培泉
北京畫家
1941年　出生
1967年　畢業於中央美術學院國畫系
1979年　參加《北京、東京聯合畫展》
1979年　參加在美國舊金山舉辦的《中國畫展》
1980年　獲北京市優秀美術作品一等獎
1981年　參加在加拿大舉辦的《北京畫院作品展》
1982年　參加在北京舉辦的《中國北京畫院、日本南畫院聯
　　　　合畫展》
1982年　獲北京市優秀美術作品三等獎

邵　飛（女）
北京畫院
1954年　　　　　　　　　出生
1975年　　　　　　　　　自學國畫
1975年　　　　　　　　　參加《中國人民解放軍全軍美術作
　　　　　　　　　　　　品展》
1975～1976～1979年　　參加《北京市美術作品展》
1978年　　　　　　　　　參加《北京畫院聯展》
1981年　　　　　　　　　參加《北京東京聯展》
1982年　　　　　　　　　參加《全國青年美術作品展》
　　　　　　　　　　　　《北京畫院赴加拿大畫展》
1983年　　　　　　　　　參加《北京畫院與日本南畫院聯展》

宋文治
江蘇省中國畫院副院長、美協江蘇省分會副主席
1919年　出生
　　　　曾在蘇州美術專科學校學習，肄業
　　　　曾從吳湖帆、張石園先生學習國畫
1979年　參加在香港舉辦的《金陵八家畫展》
1980年　參加在日本舉辦的《江蘇省國畫院畫展》
1981年　在日本東京舉辦個展
1981年　在北京舉辦個展
1982年　在南京舉辦個展
1982年　參加法國春季沙龍展

唐　雲
上海國畫院代院長
中國美術家協會上海分會副主席
1910年　出生
　　　　自學國畫
1942年　在上海舉辦個展
1944年　在上海舉辦《杯水》聯展
1947年　在上海舉辦個展
1951年　在香港舉辦個展
1963年　參加在北京舉辦的《上海花鳥畫聯展》
　　　　多次參加地方及全國性聯展

吳冠中
中央工藝美術學院教授
1919年　　　　出生
1942年　　　　畢業於杭州國立藝術專科學校，曾從潘天壽先
　　　　　　　生學習
1947～1950年　在法國巴黎國立高級美術學校蘇弗爾波（SOU-
　　　　　　　VERBIE）教授畫室學習
1948～1949年　參加法國春季沙龍展
1979年　　　　在北京、瀋陽、太原、重慶、長沙舉辦個展
1979年　　　　參加在日本福岡舉辦的亞洲美展
1980年　　　　在天津、杭州、桂林、深圳舉辦個展
1981年　　　　獲得北京市優秀美術作品二等獎
1981年　　　　在北京舉辦個展
1981年　　　　參加在尼日利亞、塞拉里昂、馬里舉辦的
　　　　　　　《詹建俊、劉煥章、吳冠中聯展》
1982～1983年　參加在日本東京舉辦的《中華二千五百年文
　　　　　　　化展》
1982年　　　　參加法國春季沙龍展
1983年　　　　參加在北京、東京舉辦的《北京畫院與日本
　　　　　　　南畫院聯展》
1983年　　　　在南京舉辦個展

吳作人
中國文學藝術界聯合會副主席
中國美術家協會代主席
中央美術學院教授
1908年　　　　出生
1927年　　　　在上海藝術大學學習西畫
1928～1929年　先後在上海南國藝術學院、南京中央大學藝
　　　　　　　術系"徐悲鴻工作室"學習
1930～1934年　先後在法國巴黎高等美術學院"SIMON·STUDIO"
　　　　　　　比利時皇家美術學院"BASTIEN STUDIO"學習
1936年　　　　在南京中央大學舉辦《畫家呂斯百、雕塑家
　　　　　　　劉開渠、畫家吳作人三人聯合畫展》
1945年　　　　在成都舉辦《邊疆畫展》及個人畫展
1946年　　　　在上海舉辦《邊疆畫展》
1947年　　　　在英國倫敦"中國學會"舉辦個展
1941～1983年　參加過歷次全國美術作品展、國外聯展

蕭淑芳（女）
中央美術學院副教授
1911年　　　　出生
1926～1930年　先後在北平國立藝專、南京中央大學藝術系
　　　　　　　學習，曾在"徐悲鴻工作室"學習
1937～1940年　先後在英國和瑞士學習水彩和雕塑
　　　　　　　在英國舉辦過個展
1949年　　　　參加第一次全國美展
1956年　　　　參加第二次全國美展
1962年　　　　參加第三次全國美展
1964年　　　　參加第四次全國美展
1979年　　　　參加第五次全國美展
　　　　　　　作品多次在國外聯展

謝稚柳
上海畫家
中國美術家協會上海市分會副主席
1909年　出生
　　　　自學國畫
1942年　在成都舉辦個展
1943年　在重慶舉辦個展
1944年　在昆明舉辦個展
1945年　在西安舉辦個展
1946年　在上海舉辦個展
1961年　在北京舉辦個展
1963年　在廣州舉辦個展
1979年　參加在日本舉辦的《大阪與上海書法聯合展覽》

亞　明
美協江蘇分會主席、江蘇省中國畫院副院長
1924年　出生
1942年　畢業於淮南藝術專科學校
1980年　在香港參加《江蘇國畫院八人聯展》
1981年　在日本參加《江蘇畫院聯展》
1981年　在合肥市舉辦個展
1982年　在新加坡舉辦《亞明、宋文治聯展》
1983年　在福州市舉辦個展
　　　　作品多次出國展出

楊　剛
北京畫家
1946年　出生
1981年　畢業於中央美術學院研究生班
1982年　參加在北京舉辦的《北京之春》畫展
1982年　參加《北京畫院、上海畫院聯合畫展》
1982年　參加在北京舉辦的《中國北京畫院、日本南畫院聯合畫展》
1982年　獲《北京之春》畫展三等獎

楊燕屏（女）
北京畫家
1934年　出生
1958年　畢業於清華大學建築系
　　　　自學國畫
1979年　參加《北京、東京聯合畫展》
1979年　參加《中華人民共和國成立三十週年美術作品展》
1981年　在北京舉辦《曾善慶、王乃壯、李秀實、楊燕屏四人聯展》
1982年　參加法國春季沙龍展

曾　宓
杭州畫家
1935年　出生
1962年　畢業於浙江美術學院國畫系
1958年　參加莫斯科舉辦的聯展
1982年　參加在北京舉辦的《浙江省中國畫展》

曾善慶
中央美術學院國畫系副教授
1932年　出生
1950年　畢業於中央美院油畫系
1951年　畢業於中央美術學院研究部，導師徐悲鴻
1963年　在北京參加過聯展
1981年　在北京參加《李秀實、王乃壯、曾善慶、楊燕屏四人聯展》
1981年　參加在東京、香港舉辦的聯展
1982年　參加在巴黎舉辦的聯展

張　步
北京畫家
1934年　出生
1963年　畢業於中央美術學院，從李可染先生學習國畫
1979年　在日本舉辦《李可染及其高徒聯展》
1980年　在日本東京舉辦個展
1980年　獲北京優秀美術作品一等獎
1981年　在北京舉辦《河山如畫圖》十人聯展
1981年　獲北京市優秀美術作品二等獎
1982年　在北京飯店美術家畫廊舉辦個展
　　　　唐山舉辦個展
1983年　在北京舉行《北京風光》九人聯展
　　　　作品多次參加國外聯展

趙秀煥（女）
北京畫家
1946年　出生
1967年　畢業於中央美術學院附屬中學
1979年　參加《北京畫院與日本東京聯合畫展》
1980年　參加《全國青年美術作品展》并獲三等獎
1981年　參加《北京畫院赴加拿大展覽》
1982年　參加在北京舉辦的《中國北京畫院、日本南畫院聯合畫展》

周昌谷
浙江美術學院國畫系副教授
1929年　出生
1953年　畢業於浙江美術學院
1955年　作品獲世界青年聯歡節金質獎章
1982年　在杭州舉辦個展
1982年　在深圳舉辦《周昌谷、諸函聯展》
1982年　在香港大會堂參加《周昌谷、黃幻吾、蕭輝榮聯展》
1982年　參加在香港舉辦的聯展

周韶華
湖北省美術院院長
中國美術協會湖北省分會副主席
1929年　出生
1950年　畢業於中原大學文藝學院美術系
1979年　獲湖北省優秀美術作品獎
1981年　參加在武漢、重慶、成都、北京舉辦的《湖北十人中
　　　　國畫展》
1981年　獲湖北省優秀美術作品獎
1982年　參加在武漢、西安、天津、福州舉辦的《晴川畫會和
　　　　申社聯展》

朱佩君（女）
成都畫院副院長
中國美術家協會四川省分會副主席
1920年　出生
　　　　自學國畫
1958年　獲《全國青年畫展》三等獎
1980年　在成都舉辦《國畫四人聯展》
1981年　獲四川省優秀美術作品獎

朱屺瞻
上海畫家
華東師範大學藝術系教授
1892年　出生
1930年　曾在日本學習西畫
　　　　自學國畫
1962年　在上海、南京、西安舉辦個展
1980年　參加在日本舉辦的聯展
1982年　在上海、南京、北京、成都舉辦個展
1982年　在廣州舉辦個展
1982年　參加法國春季沙龍展
1982年　參加在美國、印度等國的聯展

Selected Bibliography

TITLES IN ENGLISH:

A Century of Chinese Painting from the Collection of Mr. and Mrs. Kuo Ven-chi (Exhibition Catalogue). Hong Kong: 1970

Chang, Arnold. *Painting in the People's Republic of China: The Politics of Style.* Boulder, Colorado: 1980.

Chow, Johnson S.S. *Chinese Painting; the Last One Hundred Years.* Pacificulture-Asia Museum, Pasadena, California: 1974

Cohen, Joan Lebold. "Art in China Today". *Art News,* Summer 1980, pp. 69-71.

Cohen, Joan Lebold. "Drawing a Harder Line". *Art News,* September 1981, pp. 188-190.

Cohen, Joan Lebold. *Painting the Chinese Dream: Chinese Art Thirty Years After the Revolution* (Exhibition Catalogue). Northampton, Massachusetts: 1982.

Committee on Scholarly Communication with the People's Republic of China. *Traditional and Contemporary Painting in China.* Washington, D.C.: 1980.

Fuller, Peter. "Art in the People's Republic of China". *Connoisseur,* January 1975, pp. 54-56.

Hajek, Lubor, Adolf Hoffmeister and Eva Rychterova. *Contemporary Chinese Painting.* Translated by Jean Layton. London: 1961.

Hejzlar, Josef. *Chinese Watercolours.* Translated by Till Gottheinerova. First English Edition. London: 1978.

Lai, T.C. *Three Contemporary Chinese Painters (Chang Da-chien, Ting Yin-yung, Ch'eng Shih-fa).* Seattle and London: 1975.

Li, Chu-tsing. *Trends in Modern Chinese Painting.* (*Artibus Asiae* Supplementum XXXVI). Ascona, Switzerland: 1979.

Lim, Lucy. "A Hundred Flowers Blooming". *Portfolio,* April-May 1980, pp. 74-81.

Ryckmans, Pierre. *Modern Chinese Painters in the Traditional Style.* (Exhibition Catalogue). Melbourne: 1974.

Silbergeld, Jerome. *Chinese Painting Style.* Seattle and London: 1982.

Sullivan, Michael. *Chinese Art in the Twentieth Century.* Berkeley, 1959.

Sullivan, Michael. *The Meeting of Eastern and Western Art from the Sixteenth Century to the Present Day.* New York: 1973.

Sullivan, Michael. "New Direction in Chinese Art". *Art International,* vol. XXV, 1-2, 1982.

Sullivan, Michael. "Orthodoxy and Individualism in Twentieth Century Chinese Art". *Artists and Traditions: Uses of the Past in Chinese Culture,* edited by Christian F. Murck. Princeton: 1976.

Sullivan, Michael. *Trends in Twentieth Century Chinese Painting* (Exhibition Catalogue). Palo Alto, California: 1969.

Whitfield, Roderick. *Chinese Traditional Painting 1886-1966: Five Modern Masters.* London: 1982.

Wu T'ung. *Chinese Painting Since the Opium Wars* (Exhibition Catalogue). Boston: 1980.

TITLES IN CHINESE

Beijing huayuan zhanlan zuopin xuan 北京畫院展覽作品選 (*Selected Art Works from the Beijing Painting Academy Exhibition*). Hong Kong: 1982.

Beijing huayuan Zhongguo hua xuanji 北京畫院中國畫選集 (Selected Chinese Paintings from the Beijing Painting Academy). Beijing: 1982.

Chen Peiqiu hua ji 陳佩秋畫集 (*Paintings of Chen Peiqiu*). Shanghai: 1982.

Cheng Shifa huaniao xizuo 程十髮花鳥習作 (*Studies on Birds and Flowers by Cheng Shifa*). Shanghai: 1979.

Cheng Shifa jin zuo xuan 程十髮近作選 (*Selections of Recent Works by Cheng Shifa*). Beijing: 1981.

Cheng Shifa shuhua 程十髮書畫 (1-10) (*Painting and Calligraphy of Cheng Shifa,* Vols. 1-10). Hangzhou: 1978-1983.

Cui Zifan hua xuan 崔子范畫選 (*Selected Paintings of Cui Zifan*). Sichuan: 1980.

Guan Liang huace 關良畫册 (*Painting Album of Guan Liang*). Sichuan: 1982.

Guan Liang hua ji 關良畫集 (*Paintings of Guan Liang*). Hong Kong: 1981.

Haishang ming hua 海上名畫 (*Famous Painting of Shanghai*). Shanghai: n.d.

Heshan ru huatu 河山如畫圖 (*Landscape Painting*). Hong Kong: 1981.

Huaniao hua shan ji 花鳥畫扇集 (*Bird-and-Flower Fan Paintings*). Beijing: 1979.

Jindai Zhongguo hua xuan 近代中國畫選 (*Selections of Modern Chinese Painting*). Hong Kong: 1982.

Li Geng shuimohua ji (*Li Kun's World*) 李庚水墨畫集 (Brochure of Li Geng's paintings and sketches.) n.p., n.d. (Printed in Japan).

Li Geng shuimohua zuopin ji (*Lee Kun's World of Sansui*) 李庚水墨畫作品集 (Brochure of exhibition held in Tokyo, Japan, 1982.) n.p., n.d.

Li Kuchan hua ji 李苦禪畫集 (*Paintings of Li Kuchan*). Shandong: 1981.

Lin Fengmian hua ji 林風眠畫集 (*Paintings of Lin Fengmian*). Shanghai: 1979.

Meishu 美術 (*Art*). Periodical published bimonthly in Beijing.

Meishujia 美術家 (*Artist*). Periodical published bimonthly in Hong Kong.

Meishuyanjiu 美術研究 (*Studies in Art*). Periodical published quarterly by the Central Art Academy.

Renmin Wenxue 人民文學 (*People's Literature*). Periodical published in Beijing.

Shanghai huayuan Zhongguo hua zhuan ji 上海畫院中國畫專集 (*Chinese Paintings from the Shanghai Painting Academy*). Shanghai: 1979.

Shanghai Zhongguo hua xuanji 上海中國畫選集 (*Selected Chinese Paintings from Shanghai*). Shanghai: 1979.

Wang Zhuo, ed. 王琢 *Li Keran hua lun* 李可染畫論 (*Discussions on Paintings by Li Keran*). Shanghai: 1982.

Wenyi bao 文藝報 (*Literature and Art*). Periodical published monthly in Beijing.

Wu Guanzhong cai hua sumiao xuan 吳冠中彩畫素描選 (*Selected Paintings and Sketches of Wu Guanzhong*). Shandong: 1979.

Wu Zuoren, Xiao Shufang hua xuan 吳作人，蕭淑芳畫選 (Selected Paintings of Wu Zuoren and Xiao Shufang). Beijing: 1982.

Xiandai Zhongguo hua xuan 現代中國畫選 (1-3) (*Modern Chinese Paintings,* Vols. 1-3). Beijing: 1977.

Xiandai Zhongguo hua ji cui 現代中國畫集粹 (*Modern Chinese Painting*). Beijing: 1981.

Xie Zhiliu, Chen Peiqiu hua ji 謝稚柳，陳佩秋畫集 (Paintings of Xie Zhiliu and Chen Peiqiu). Hong Kong: 1980.

Xie Zhiliu hua ji 謝稚柳畫集 (Paintings of Xie Zhiliu). Shanghai: 1981.

Ya Ming zuopin xuanji 亞明作品選集 (Selected Paintings of Ya Ming). Hong Kong: n.d.

Yiyuan 藝苑 (*Art Selections*). Periodical published quarterly in Nanjing.

Zhongguo hua 中國畫 (*Chinese Painting*). Periodical published in Beijing.

Zhongguo hua yanjiu zuopin xuanji diyiji 中國畫研究院作品選集第一集 (*A Collection of One Hundred Contemporary Paintings of the Chinese Painting Research Institute,* Vol. 1). Beijing: n.d.

Zhongguo shuhua 中國書畫 (*Chinese Painting and Calligraphy*). Periodical published in Beijing.

Zhongri hetong meishu zhan hua ji 中日合同美術展畫集 (*Catalogue of the Joint Exhibition held by China and Japan* [Beijing, September 1982]). n.p., n.d. (Printed in Japan.)

Zhou Shaohua hua ji 周韶華畫輯 (*Portfolio of Paintings by Zhou Shaohua*). Beijing: 1981.

Zhu Qizhan hua ji 朱屺瞻畫集 (*Paintings of Zhu Qizhan*). Shanghai: 1980.

Photo: Kit Luce

Chinese Names and Terms

Ai Qing	艾青	Hua Yan	華嵒
Bada Shanren	八大山人	Huang Binhong	黃賓虹
baihua qi fang	百花齊放	Huangshan	黃山
baimiao	白描	Ji Kang	稽康
Chan	禪	Jiang Qing	江青
Chen Hongshou	陳洪綬	Jiangnan	江南
Chen Qikuan	陳其寬	*Jieziyuan Huazhuan*	芥子園畫傳
cun	皴	Jin Nong	金農
Dai	傣	jinbi	金碧
dan	淡	Jinling	金陵
dian	點	Kuncan	髡殘
Dong Yuan	董源	Lin Fengmian	林風眠
fang	仿	Lingnan Pai	嶺南派
Fu Baoshi	傅抱石	Liu Guosong	劉國松
fupi cun	斧劈皴	Liu Lingcang	劉凌滄
gongbi hua	工筆畫	Lu Xun	魯迅
Gu Kaizhi	顧愷之	Mao Zedong	毛澤東
Guhua pinlu	古畫品錄	Meishuguan	美術館
Guilin	桂林	Mi Fu	米芾
Guo Moruo	郭沫若	mogu hua	沒骨畫
Guo Xi	郭熙	Pan Tianshou	潘天壽
guohua	國畫	pima cun	披麻皴
Guomindang	國民黨	pomo	破墨
Haipai	海派	pomo	潑墨
hua	畫	Qi Baishi	齊白石
Hongren	弘仁	Qian Songyan	錢松嵒

qin	琴	Zhang Daqian	張大千
Ren Bonian	任伯年	Zhao Chang	趙昌
Ren Xiong	任熊	Zhao Wuqi	趙無極
Shen Zhou	沈周	Zhao Zhiqian	趙之謙
Shi ji	史記		
Shitao	石濤		
Sima Qian	司馬遷		
Tiananmen	天安門		
Wang Hui	王翬		
Wang Jiqian	王己千		
Wang Yuanqi	王原祁		
Wang Zeqing	王澤慶		
Wang Zhuo	王琢		
wenren hua	文人畫		
Wu Changshi	吳昌碩		
Xie He	謝赫		
xieyi	寫意		
xieyi hua	寫意畫		
Xinjiang	新疆		
Xu Beihong	徐悲鴻		
Xu Wei	徐渭		
Xu Xi	徐希		
Xugu	虛谷		
Yangzhou baguai	揚州八怪		
Yenan	延安		
Yu Feian	于非闇		

Note:
These are Chinese names and terms referred to in the essays. The names of the thirty-six artists and the titles of the paintings in the exhibition are not included on this list. Please refer to the catalogue entries for them.